Salvador Dalí

BY ROBERT GOFF

THE WONDERLAND
PRESS

Harry N. Abrams, Inc., Publishers

THE WONDERLAND PRESS

The Essential™ is a trademark
of The Wonderland Press, New York
The Essential™ series has been created by The Wonderland Press

Design by DesignSpeak, NYC

Library of Congress Catalog Card Number: 98-71952
ISBN 0-8362-6996-9 (Andrews McMeel)
ISBN 0-8109-5800-7 (Harry N. Abrams, Inc.)

Distributed by Andrews McMeel Publishing
Kansas City, Missouri 64111-7701

Unless caption notes otherwise, works are oil on canvas

Printed in Hong Kong

Harry N. Abrams, Inc.
100 Fifth Avenue
New York, NY 10011
www.abramsbooks.com

Contents

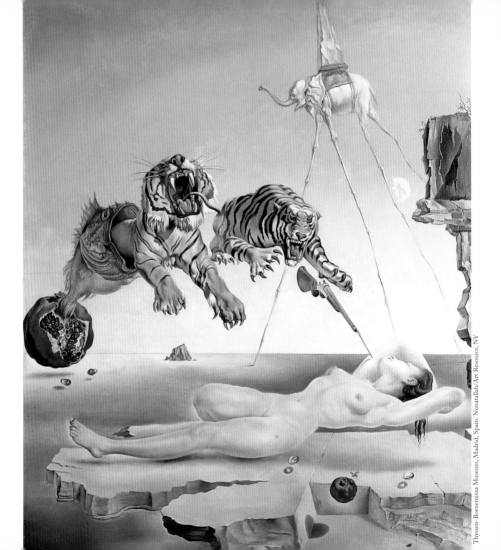

Salvador Dalí: Artist, Genius, Showman—or Fraud?

Mention the name Salvador Dalí to five people and ask what comes to mind. They'll probably all answer: Melting watches and a handlebar moustache. And if you ask them what Dalí's melting watches actually *mean*, you'll likely get five different answers.

Many people look at Dalí's art and honestly don't *get* what he's trying to present. His dreamlike landscapes depict:

- **melted objects** dripping from tree limbs

- **loaves of bread** that stretch into phallic shapes

- **tigers** flying through the air above nude women sleeping

- **drawers** that open up from human bodies

- **crutches** that prop eyelids and chins of distorted human forms

Salvador Dalí is one of the most puzzling, controversial, and wildly successful artists of the 20th century. People are fascinated by his strange pictures, which hang in museums and sell in poster shops throughout the world. His memoirs have been bestsellers. His contributions to pop culture, fashion, and advertising have been cleverly inventive. His face, with its signature moustache and bulging eyes, is instantly recognizable.

OPPOSITE
One Second Before Awakening from a Dream Caused by the Flight of a Bumblebee Around a Pomegranate 1944. 20 ⅛ x 16" (51.1 x 40.6 cm)

Yet to most people, Dalí remains a weird and fascinating enigma. Was he really the great artist he claimed to be? Or was he a genius at making us believe this?

Truth is, Dalí was an artist of real intellectual substance and painterly talent. Surrealism—the movement he helped to popularize internationally—is one of the most important artistic and literary movements of the 20th century. *No responsible discussion of modern art and culture can ignore Dalí.* His reputation is tarnished, however, by the perception that he was too greedy for money and publicity, and by the controversy, at the time of his death, over phony Dalí prints that had flooded the marketplace. The Surrealist poet, artist, and theorist **André Breton** (1896–1966) called him "Avida Dollars"—an anagram of his name meaning "eager for dollars."

Have Fun !

The key to enjoying Dalí is…to *enjoy* him! If you're new to Dalí or wonder what's going on in his paintings, this book will open the door

OPPOSITE

TOP LEFT
Photo of Figueras apartment house

BOTTOM LEFT
Photo of Cadaqués house

NEAR LEFT
Photo of Salvador Dalí

7

for you. Even if you're unable (at this point) to explain one of his paintings or tell why you like (or dislike) it, you'll know intuitively what it means, because Dalí's art speaks to the heart. Trust your instincts: They will be correct. Have fun figuring out his symbols and playing games with his optical illusions. They bypass language, culture, and education.

First Things first

Before going further, here are two things to know that we'll come back to, but that will get you in the loop immediately:

- **DALÍ'S NONSENSE:** Dalí was a serious artist, of true depth and genius, but he loved capers and tricks and giving odd names to his "theories" and paintings (e.g., *Average Atmospherocephalic Bureaucrat*). Ignore these for the moment, because even his most complex-sounding ideas are very simple, and we explain them all in this book. Language was one of his games.

- **FREUD AND SURREALISM:** The two major influences on Dalí were: the Austrian psychoanalyst **Sigmund Freud** (1856–1939), whose theories on the "unconscious" and on dream interpretation were the basis of the Surrealists' efforts; and **Surrealism,** the artistic and literary movement arising in the 1920s that sought to express the inner workings of the mind through writing and visual imagery. Okay, now you're ready!

8

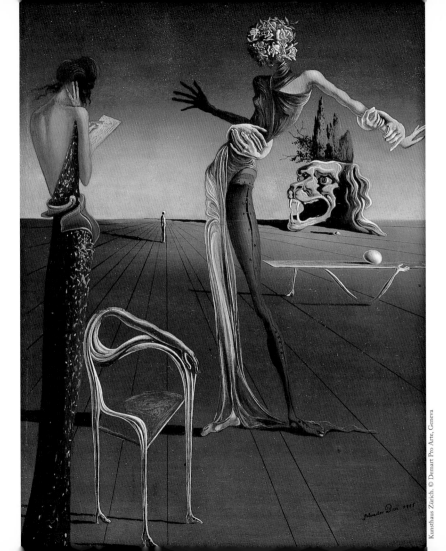

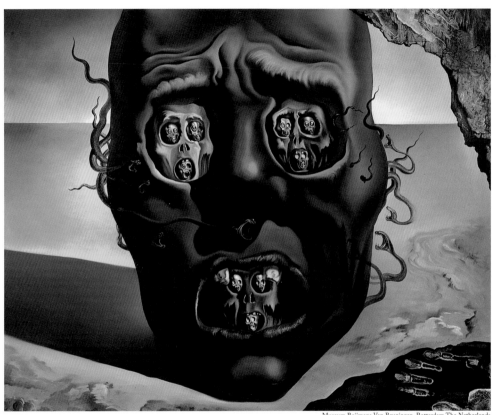

Museum Boijmans Van Beuningen, Rotterdam The Netherlands

What's so Great about Salvador Dalí?

Dalí's life and art are inseparable. Once you understand the events of his life, you'll appreciate the meaning of his art and ideas. His paintings are about dreams, desires, and memories—those of a childhood spent on the rocky Catalonian coast of Spain, the far northeastern region near the French border, which boasts its own fiercely independent history and spirit. For the rest of his life, he converted the signs, symbols, landscapes, and experiences of those early years into material for his art.

This is the story of a painter who began life in a small town and who went on to achieve unrivaled acclaim in the international worlds of art, culture, and society. Long before the era of **Michael Jackson** and **Madonna,** Dalí happily reinvented himself each day and was virtually a performance artist. From an early age, he was driven by a need for money, fame, love, and acceptance as a genius and great artist. To the amusement of his admirers and disdain of his critics, Dalí delighted in endless self-promotion and marketing stunts, unafraid of declaring himself the only true Surrealist and the greatest artist ever to live. A role model for **Andy Warhol** (1928–1987), Dalí was for years the eternally adolescent jester of the art world, shamelessly embracing the cult of fame and celebrity.

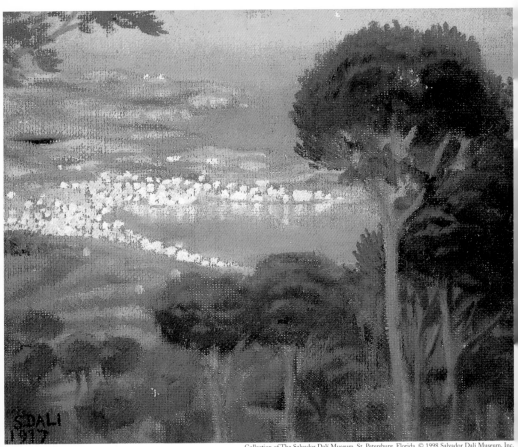

What influences drove Dalí?

Dalí was committed to Freud's idea that childhood experiences mark us for life. The two big influences on his work were:

OPPOSITE
*View of Cadaqués
with Shadow of
Mount Pani.* 1917
15 ½ x 19"
(39.4 x 48.3 cm)

1. **LANDSCAPE:** His independent Catalan spirit and love for the dramatic coastline of his family's beloved vacation home in Cadaqués stayed with him from childhood to death.

2. **SEXUAL AMBIGUITY AND FEAR OF SEX WITH WOMEN:** From an early age, Dalí feared sexual relations with women. His writings tell us that as a sexually inexperienced adolescent, he found himself attracted to, yet troubled by, the sexual interest he received from men. Sexual ambiguity and fears of impotence are major themes in his work. Though the idea of heterosexual relations alarmed him, Dalí was drawn to strong women—first to his mother, later to his wife, **Gala** (c. 1894–1982)—whom he transformed from physical beings into goddesses and Virgin Mary figures.

> *FYI*: **How to Pronounce "Dalí"**—The Spanish stress the final "i," as in "dahLEE." But most people say "Dolly," as in "Hello Dolly." His name, spelled correctly, has an accent over the "í," but often the accent is missing, sometimes even in Dalí's own signature. Frequently his works are unsigned. After his marriage to Gala, Dalí often signed his name "Gala-Dalí" to express the total merging that, in his mind at least, had taken place between himself and Gala.

An Artist's Context

Catalonia (also spelled "Catalunya"), the region in northeastern Spain that extends from the French border and tiny principality of Andorra in the eastern Pyrenees and down the Mediterranean coastline, has a fiercely independent spirit rooted in centuries of cultural and political differences with the rest of Spain. It has its own language, Catalan, distinct from Castillian Spanish, and a historically strong commitment to the fine arts, owing largely to its prosperous economy.

Its stunningly beautiful capital city of Barcelona, second only to Madrid as the great artistic and intellectual hub of the Spanish-speaking world, has been home to some of Catalonia's best-loved artists, including the architect **Antonio Gaudí** (1852–1926), designer of the magnificent and unfinished church, La Sagrada Familia, and painters **Joan Miró** (1893–1983) and **Pablo Picasso** (1881–1973), who was born in Málaga but who studied in Barcelona for several years.

Sound Byte:
"All the eccentricities that I commit, I do because I wish to prove to myself that I am not the dead brother, but the living one."

—DALI

Early signs of a Myth

Dalí was born on May 11, 1904 in the small Catalan town (pop. 13,000) of Figueras (also spelled Figueres) to affluent, socially prominent parents. His authoritative father, **Don Salvador Dalí y Cusi,** was a notary and legal expert, much sought after in business affairs, and an atheist in a devoutly Roman Catholic country. Dalí's mother, **Felipa,** was a kind, hardworking homemaker from a solidly bourgeois Barcelona family and a pious Roman Catholic. Dalí's parents adored him and his younger sister, **Ana María,** born three years after Dalí in 1907.

So, his story begins: The young Dalí grows up in a posh apartment dominated by women—his mother, sister, aunts, grandmother, and nurse. Doted on by them, Dalí plays the role of precocious young lord, spoiled and prone to dramatic fits of temper. Lifelong phobias, such as his fear of grasshoppers, begin during this time, and only his trusted and beloved mother is able to soothe his worst tantrums.

An Obsession: the "Replacement" Salvador

From an early age, Dalí thinks of himself as a "replacement child." An older brother, also named Salvador Dalí, died of meningitis at age two, nine months before the "next" Salvador came into the world. A portrait of the earlier Salvador hangs prominently in his parents' bedroom next to a painting by Velázquez, a constant reminder of the sadly

Portrait of My Father. 1925
39 ³/₈ x 39 ³/₈"
(100 x 100 cm)

missed first son. Dalí later claims that his unknown brother's death has been the foundation of his own complicated personality.

Dalí's relationship with his conservative father is strained by the future artist's urges for bizarre behavior. Attempts at paternal discipline meet with outrageous acts of rebellion. Dalí feels a stronger, safer bond to his mother.

First Paintings and two early Influences

By the age of four, Dalí is already drawing on the dining room table-cloth. In 1914, at the age of 10 and encouraged by his father's friend, the wealthy Spanish Impressionist painter **Ramón Pichot** (1872–1925)—who is also a friend of Picasso's—Dalí completes his first painting, a landscape called *Paisaje.* He decides to become a painter while visiting Muli de la Torre, the Pichot family's operating mill (and vacation home) where he comes in contact with cultured and talented guests. Dalí later writes that Pichot's paintings impressed him because they represented his first contact with "an anti-academic and revolutionary theory." World War I has just begun (1914) and lasts four more years, with little influence on the sheltered and affluent Dalí family.

Sound Byte:
"With each passing day I feel myself...virtually nailed to my geology."
—DALI, 1939

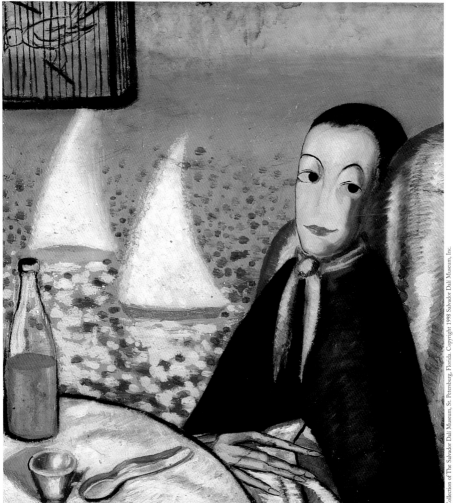

One, Two, Three...

Dalí's first paintings are of landscapes, houses, olive trees, portraits, and boats. From the beginning, his colors are bright and exuberant—a trait that lasts throughout his career and is revealed in an early self-portrait, *The Sick Child* (1914–15). This painting, which features Dalí himself, shows his masterly use of rich hues and an eagerness to experiment with artistic technique—here, in the form of Impressionistic, dabbed-on brushstrokes of light reflecting on the water.

The Catalan landscape inspires in him a sense of drama and awe. The two distinctive landscape images that recur over and over in his paintings are: the great promontories of granite rock that jut out from the coast near Cadaqués, the fishing village where the Dalís keep a summer home; and the melancholy plains of Ampurdán, where Figueras is located.

Early Promise

While he is a high school student (1917–21), Dalí studies drawing and printmaking, and has his first exhibition, in 1918, at the town theater. His work meets with great acclaim. As he reveals in his 1942 autobiography, *The Secret Life of Salvador Dalí,* the teenage Dalí, troubled by anxieties about sexuality, finds comfort in his art and searches for meaning in a wide range of artistic and intellectual pursuits:

Sound Byte:

"Dalí, a man who can feel the light, is already one of those artists who will cause a great sensation, one of those who will produce great pictures. We welcome this new artist and express our belief that at some point in the future our humble words will prove to be prophetic."

—A newspaper critic, writing about
the 15-year-old Dalí in 1919

- by 1918, at age 14, he is already **actively interested in Cubism**

- even prior to reading Freud, Dalí is interested in psychology. And he reads books from his father's library by the great philosophers **Voltaire** (1694–1778), **Immanuel Kant** (1724–1804), and **Friedrich Nietzsche** (1844–1900)

- though Dalí is an average student, he shows **precocious artistic talent.** In a 1919 diary entry, the 15-year-old proclaims, "I'll be a genius and the world will admire me"

- he plays the dandy and is often beaten up by the other boys in his class—which only encourages him to become even more outrageous. He wears his mother's powder to give himself the pale look of the bohemian artist; he grows long sideburns, sports fancy jackets and capes, and carries a walking stick

An artistic movement, begun in 1908 by Picasso and **Georges Braque** (1882–1963), that abandoned efforts to depict subjects in traditional three-dimensional perspective in favor of showing them on the two-dimensional flat surface of a canvas, with overlapping and rearranged fragments that evoked a subject's inherent complexity. Other Cubist artists included **Juan Gris** (1887–1927) and **Fernand Léger** (1881–1955). Futurism, an Italian movement related to Cubism, celebrated the energy and speed of modern life in works that frequently took machines, cities, and dynamic physical move ment as their subject. Proponents included **Filippo Tommaso Marinetti** (1876–1944) and **Giacomo Balla** (1871–1958).

- in 1919, he cofounds and contributes articles to a student magazine, *Studium,* on paintings of Old Masters such as **Francisco de Goya** (1746–1828), **El Greco** (1541–1614), **Michelangelo** (1475–1564), and **Velázquez** (1599–1660)

- a young anarchist and defender of Catalonian independence, he is keenly interested in politics and supports the Russian revolution, led by **Nikolay Lenin** (1870–1924)

Traumatized by his Mother's Death

On February 6, 1921, Dalí's beloved mother dies of cancer. The painter never recovers from this trauma and is appalled when his father soon marries the sister of Dalí's mother. Moreover, the loss stimulates a dramatic turning point in his art: Having painted portraits and landscapes, Dalí now begins making images that reflect his **tormented soul.** He samples numerous artistic styles and borrows from them as he sees fit: still lifes, landscapes, portraits, and oil paintings in realist, Impressionist, and neo-Cubist styles. His first one-man exhibition outside of Figueras is in January 1922 at the prestigious Galería Dalmau in Barcelona. The reviews are enthusiastic.

FEDERICO GARCÍA LORCA

Lorca, five years older than Dalí and for many years his closest friend, had become one of the 20th century's great poets by the time of his violent death by firing squad, at the hands of right-wing fascists, during the Spanish Civil War in 1936. A gifted musician, Lorca also wrote several important plays *(Yerma, The House of Bernarda Alba,* and *Blood Wedding).*

Lorca and Dalí
1925. Photography
by Ana María Dalí

Though they met at the Resi, Dalí's friendship with Buñuel blossomed when Dalí moved to Paris in 1929 and they co-authored Buñuel's famous movie, *Un Chien andalou*. The film was an instant success in Parisian avant-garde circles and was proclaimed the first Surrealist film. The two friends also collaborated on *L'Age d'or*, which premiered in Paris in November 1930 but which was quickly banned in response to a violent attack by pro-fascist party members. Buñuel's career as a filmmaker declined steeply after this setback. He moved to Mexico in 1947, and only late in life did he stage a comeback with major films like *The Discreet Charm of the Bourgeoisie* (1972) and *The Obscure Object of Desire* (1977).

OPPOSITE
Hieronymus Bosch
Garden of Earthly Delights
(detail of the right panel)
c. 1505–15. Oil on panel

Friendships with Future Greats

In October 1921, Dalí arrives in Madrid to study at the Royal Academy of Fine Arts of San Fernando, a school for painters, sculptors, and engravers. The Academy is acceptable to Dalí's father, since it will provide Dalí with official teaching credentials.

Dalí takes up quarters in La Residencia de Estudiantes, known informally as the "Resi." Since he has grown up in a cultural haven and has trained in Barcelona, he had been in contact with the new European artistic initiatives. His knowledge of the avant-garde makes Dalí an attractive companion to his colleagues at school. Dalí's most important influences at the Resi are the close friendships he develops with the poet **Federico García Lorca** (1899–1936) and filmmaker **Luis Buñuel** (1900–1983).

Dalí adopts a quiet existence, secluding himself in his small dorm room and painting around the clock. With canvases strewn all over, visitors have to carefully dodge the mess. He impresses teachers with his drawing skills and ambition. On weekends, he visits the Prado Museum to copy Old Masters' paintings, especially those of **Hieronymous Bosch** (1450?–1516), whose landscapes of hell and damnation resonate deeply in Dalí's mind.

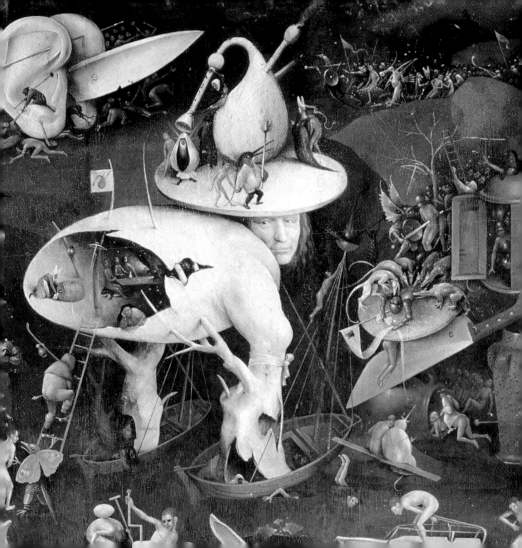

Dalí is especially interested in the Cubist paintings of Picasso and of Juan Gris. His 1923 *Self-Portrait with "La Publicitat"* is one of Dalí's best attempts at Cubism and bears the undeniable mark of his huge ego: Although he has spliced up and rearranged the background, clothes, and newspapers in the geometric form of Cubism, Dalí leaves his own face somewhat intact, as if to proclaim that Cubism, no matter how important, can never disassemble the great Dalí.

Dalí's enthusiasm for the avant-garde catches the attention of Lorca, Buñuel, and the Resi's "in" crowd. As they become his friends, Dalí emerges from his solitude and accompanies them to bars and cafés, listening to music and discussing politics and gaining a taste for the snobbery of those who fancy themselves an elite.

Unlike other art students, Dalí is restless with the Impressionist style encouraged by his teachers, many of whom he regards as his inferiors. He wants strict rules in order to acquire rigorous training in traditional

ABOVE
*Portrait of
Luis Buñuel*
1924
27 ¹/₂ x 23 ⁵/₈"
(70 x 60 cm)
Private Collection

OPPOSITE
*Self-Portrait with
"La Publicitat"*
1923. Gouache
and collage on
cardboard
41 ¹/₄ x 29 ¹/₄"
(104.78 x 74.30 cm)

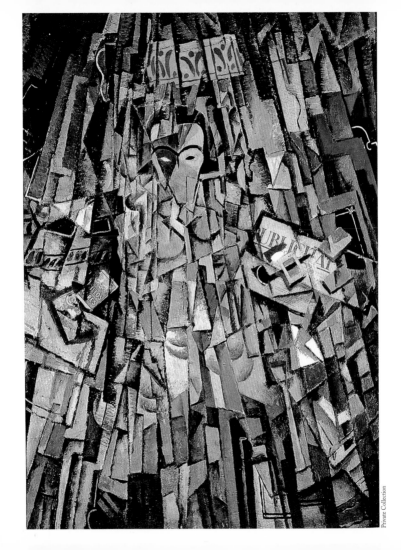

techniques that he believes he will need to launch himself as the kind of artist he wants to be. Not surprisingly, Dalí finds himself at odds both with the administration and the other students.

Dalí and his friends develop their own slang and terminology that only they understand. Some of the main symbols and code words eventually end up in Dalí's work. Revolted by romantic, traditional forms of art, the artistic revolutionaries use the term *putrefacto* (the root word "putrefaction" means "decay" and is often symbolized in Dalí's paintings as a rotting whale or donkey) to describe their revulsion for bourgeois pursuits and conventional thinking.

OPPOSITE
Venus and the Sailor. 1925
85 x 57 ⅞"
(216 x 147 cm)

The Discovery of Freud

In 1922, Dalí reads Freud's *The Interpretation of Dreams* (1900) and the writings of the French Surrealists, in particular those of their leader, André Breton, and of the poet **Paul Eluard** (1895–1952), whose wife, Gala, will eventually leave the poet to marry Dalí.

Freud's theories on dreams have such an immense influence on the impressionable Dalí that they change forever the essentials of his art. Dalí's interests and energies, from this point onward, become channeled through the lens of Freudian psychoanalytic theory.

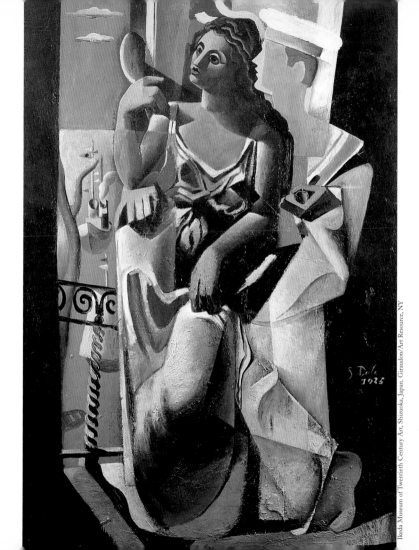

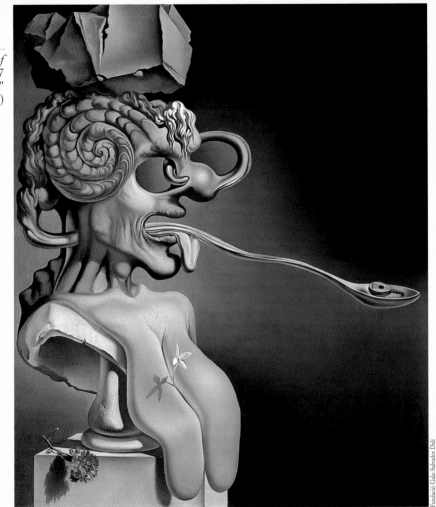

Portrait of Picasso. 1947
25 ¹/₄ x 21 ¹/₂"
(64.1 x 54.6 cm)

Freud's ideas about the unconscious are as important to Dalí on a personal level as on a professional one as he struggles to understand his own dreams and inner conflicts. He writes extensive notes in his copy of Freud's book, which will influence his future themes, symbols, settings, and techniques. Freud's major contribution to psychology is his "discovery" of the unconscious. A quick recap of Freud's dream theory and how Dalí uses it will illuminate the influence Freud has on Dalí:

1. The psyche, or mind, is composed of conscious and unconscious parts: Beneath the rational, civilized, conscious state (made up of *ego* and *superego,* or "conscience") there exists an irrational, animalistic, unconscious mind that Freud calls the *id.*

2. The unconscious is the source of libido, or sexual drive, and of powerful primitive instincts that are "repressed" during the time when a young infant is first exposed to the process of socialization (e.g., bottle feeding, potty training). Since it is unnatural for instincts to be silenced, they forever seek to push their way into consciousness, regardless of social pressure from the ego to keep them repressed.

3. Censorship from the conscious: Civilized society can exist only when people behave in rational, socialized ways. Chaos would result if unconscious impulses ruled our actions. To safeguard us from being overwhelmed by the intrusion of repressed instincts into our conscious lives, our ego "censors" these instincts.

4. Dreams: Since our unconscious instincts will not be silenced, the psyche has a mechanism for them to express themselves without interfering in our daily lives: dreams. Through dreams, impulses are transformed and disguised so that their contents (known as the *dream text*) do not alarm us. Example: The dream text might be, "My relationship with my lover is falling apart," but the expression of this "text" might be a human heart crawling with ants. When we fall asleep, the censorship barrier of the ego relaxes and our primal desires push into our "sleeping" conscious mind in an attempt to work through our unresolved conflicts. When we wake up, we remember the weird signs and symbols of our dreams, but not the "dream text" itself.

5. Dream processes: This "weirdness" is the result of three processes that make our dreams palatable to the sleeping conscious mind. Dalí incorporates these processes into his painting: **condensation, displacement, and sublimation.** Condensation refers to the splicing of two or more ideas, memories, or impulses into one "shared" symbol: What appears to be an eye or a nose in a dream,

may also contain crawling ants, a tree limb, or a phallus. We look at these and think, "Huh???" But there's more: Dreams also take a thought or emotion that is ordinarily associated with one type of experience and, by displacement, shift it onto another seemingly unrelated object (e.g., sexual desire displaced onto a bird's wings or a staircase; components of our memory, expressed in the form of drawers). This mechanism displaces intolerable emotions from the source of anxiety onto a neutral act or object: Though you may be afraid of flying, you may have no fear of a baby's pacifier, so the pacifier may suddenly sprout wings in your dream, thereby allowing you to focus on the act of flying without feeling the fear associated with an airplane. With sublimation, the conscious mind replaces an intolerable act (e.g., playing with feces) with one that is symbolically related to it but acceptable to the conscious (e.g., playing with mud pies, then playing with clay, then becoming a sculptor). The three processes of condensation, displacement, and sublimation take the raw materials of our unconscious and transform them into "weird" but tolerable *symbols*. Dalí similarly transforms unconscious raw material into symbolic visual dreams for contemplation by the viewer's conscious and unconscious mind.

6. Enter Surrealism: The dream texts are purposeful, not random, and are intricately woven with symbols drawn from our conscious lives, then condensed and displaced in nonlinear fashion. We identify a human nose, but its meaning may escape us in a dream where it sits atop a telephone pole, swarmed with bees. These symbols represent a dimension that transcends the "real" world and enters a realm that is more-than-real, or **Surreal.** The expression of impulses from this Surreal world becomes the focus of Dalí and the Surrealists— with the difference being that the Surrealists concentrate their efforts on *pure psychic automatism* (Breton's words) and chance effects, as if channeled by a transmitter, whereas Dalí makes conscious choices of irrational (*paranoiac* or "hallucinatory") material and places this material consciously in his paintings as representations of unconscious impulses.

7. Paranoiac-Critical Method: While it is true that Dalí participates in the Surrealist movement of the 1920s and 1930s, his contributions to Surrealism go beyond the techniques of automatic writing and free association of ideas that Surrealists are known for. Freud's ideas open up the dream world of the unconscious to Dalí, enabling him to create his own approach to Surrealism known as the *paranoiac-critical method*. He perceives the *psychic automatism* of the other Surrealists to be an inefficient way of expressing the unconscious and prefers instead to *organize* the **paranoia** (unconscious dream material) in a conscious, intellectual manner (this is the **critical** component). His approach gives artists a method for organizing their own obsessions and presenting them on the canvas in a way that helps them know themselves better.

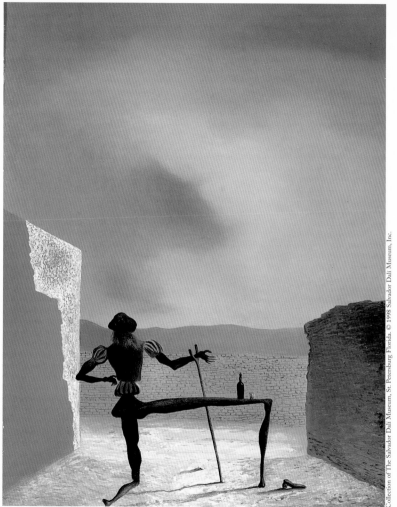

The Ghost of Vermeer of Delft Which Can Be Used as a Table
Oil on panel
7 ⅛ x 5 ½"
(18.1 x 14 cm)

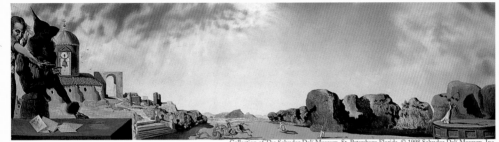

SURREALISM

A literary and artistic movement that began in about 1922 in Paris as an outgrowth of the avant-garde movement known as Dada, which had been mocking technological "advances" and smug bourgeois thinking. Surrealism rejected Dada's largely skeptical tone in favor of a more positive search for "the new society." Led by the French poet and theorist André Breton (1896–1966), the Surrealists pursued the "true functioning of the mind" (Breton) by lodging a "law suit against reality." They sought to unleash the instincts and impulses of the unconscious by means of *automatic writing* and painting (which Breton called *pure psychic automatism*), in which the artist bypasses his/her conscious willpower and lets unconscious impulses guide the hand in matters of line, color, and structure, without rational or planned "interference." The movement was more suited to writers than to artists, since the free flow of impulses could be channeled more quickly onto the page than onto a canvas. Realizing the limits of psychic automatism, Dalí resisted joining the Surrealists until 1929, when he saw that Breton was flexible about moving beyond beyond psychic automatism. Besides Dalí, major artists in the movement were Marcel Duchamp (1887–1968), Yves Tanguy (1900–1955), René Magritte (1898–1967), Max Ernst (1891–1976), and Giorgio de Chirico (1888–1978).

OK Now you see how Freud's influence on Dalí's codes and visual language works, and how Dalí makes connections between the unconscious material (the *dream text*, or, in his terminology, the *paranoia*) and the consciously chosen symbols depicting the inner workings of the mind. In Dalí's art, the concept of time, space, and the physical nature of objects in the conscious world gives way to a timeless, "placeless," physically transformed, dreamlike universe with its own taxonomy of meanings. This is the theoretical underpinning of all of Dalí's works after the early 1920s.

OPPOSITE
Anthropomorphic Echo. 1937
Oil on panel
5 ⅝ x 20 ⅜"
(14.3 x 22.9 cm)

Back to School: Oops, Suspended!

During the time of Dalí's residence at the Academy, Spain is becoming divided (as is the rest of Europe) between the warring parties of fascism and communism. The Madrid government fears a Catalan uprising, and Dalí, proudly Catalan, refuses to conform to any rigid system, artistic or political. He is therefore a natural target for expulsion from the Academy—and from Madrid. The Academy suspends him for a year (1923–24) for allegedly inciting a student protest. (He is innocent.) Dalí returns home to Figueras.

Imprisoned in Figueras

In May 1924, Dalí is arrested in Figueras for political subversion and jailed for one month. (This has more to do with his father's forceful stand

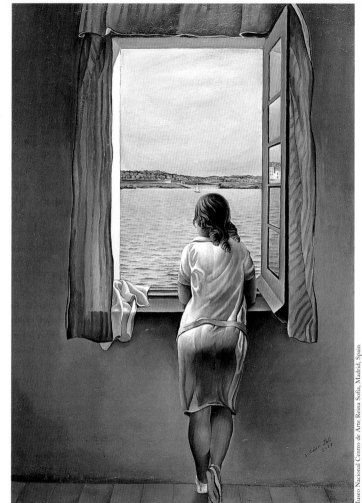

*Girl Standing
at the Window*
1925
40 ½ x 29 ½"
(103 x 75 cm)

Museo Nacional Centro de Arte Reina Sofía, Madrid, Spain

against the right-wing Spanish government than with anything that Dalí himself has said or done.) Dalí later brags that his prison sentence was a welcome vacation, giving him time to read, write, sketch, and think. In fact, among Catalans it is a badge of honor to spend time in prison.

When Dalí returns triumphantly to Madrid in September 1924, he resumes the life of a dandy, painting and socializing with his friends, though still suspended from the Academy.

Federico García Lorca 1927

Dalí's Increasing Closeness to Lorca

Darkly handsome and charming, Federico García Lorca is the unofficial leader of a small group of close friends at art school. Dalí and Lorca become close friends and collaborators. When Dalí draws venomous caricatures of "putrefactos"—to him, loathsome middle-class Spaniards—Lorca pens disparaging verses to accompany them. As their relationship deepens, Dalí paints Lorca obsessively. Though Lorca is gay, Dalí is sexually immature; he has never felt certain of his sexual desires and suffers from fears of heterosexual relations. Lorca falls in love with Dalí and perhaps Dalí reciprocates, though he later denies having had sex with Lorca. (Photos showing the two men together reveal a special closeness. So who knows?) Lorca spends part of the summer of 1925 with the Dalí family at their home in Cadaqués and makes his feelings about Dalí public in his "Ode to Salvador Dalí."

By fall, Dalí begins classes again at the Academy. In November 1925, he has his first one-man show at the Galería Dalmau in Barcelona and his works are received warmly by the critics. Picasso visits the show and returns to Paris enthused about Dalí. The exhibition includes the neo-Cubist *Venus and the Sailor* (p. 27) and two examples of his recent realist paintings, *Portrait of My Father* (p. 15) and *Girl Standing at the Window* (p. 34), featuring Dalí's sister, Ana María. *Portrait of My Father* reveals Dalí's perception of his father as an authoritarian of considerable presence. His family objects to Dalí's having placed his father's hand over his crotch in the painting, but Dalí laughs it off.

First Trip to Paris

In the spring of 1926, Dalí visits Paris for the first time with his aunt and sister. Buñuel is there and introduces him to the leaders of the Parisian avant-garde. Dalí meets Picasso and tells him, "I have come to see you before visiting the Louvre." Picasso responds, "You were not wrong."

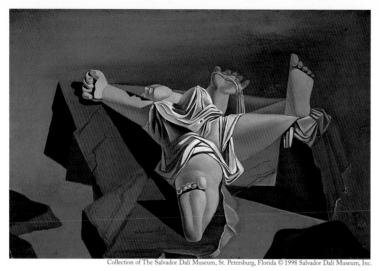

Figure on the Rocks (Femme Couchée). 1926
Oil on panel
10 ³/₄ x 16"
(27.3 x 40.6 cm)

Return to Figueras

Like a whole generation of artists before him, Dalí knows that his destiny will be made in Paris. As he leaves the city after this brief first visit, he is already plotting his return. During his exams at the Academy the summer of 1926, Dalí, by now sick of art school, refuses to participate in his Theory of Fine Art exam, arguing that his professors are not competent to judge him. The Academy expels him, he returns to Figueras, and his father is once again angry with his willful son.

In Figueras, Dalí struggles to develop a personal style, though still under the influence of Picasso, as reflected in the neo-Cubist *Figure*

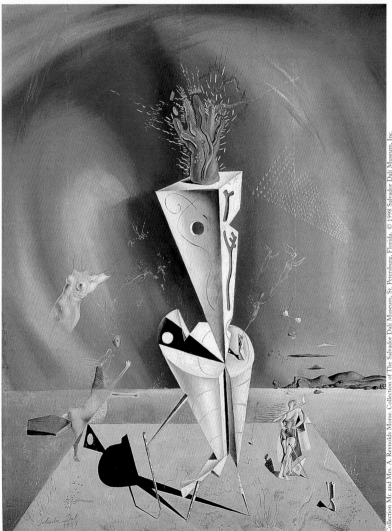

on the Rocks. Focusing on the geometry of his figure and not on colors, Dalí is especially intrigued by the contrast between the woman's softness and the hardness of the rocks.

In late 1927, Dalí paints the pre-Surrealist *Apparatus and Hand,* in which the central geometrical figure, a vestige of his experiments with Cubism, is surrounded by symbolic elements lifted from a dream. The transitional painting reflects the stylistic influence of Picasso but points to the increasing importance of Freud in Dalí's work. The features that will become part of his mature style include:

OPPOSITE
Apparatus and Hand. 1927
Oil on panel
24 ½ x 18 ¼"
(62.23 x 46.36 cm)

- **APPARATUS:** Contrived objects and weird machines (apparatuses) play a central role in the Dalinian universe. The cone and obelisk are precariously propped up by stilts, defying gravity. The tensions and restraints of conscious life are absent, replaced by a humanoid shadow and by timeless, spaceless objects that require support.

- **WOMEN AS OBJECTS:** A plaster cast of a woman with cementlike breasts floats next to a decaying fish that flies through the air. Her mutilated three-dimensional body is contrasted to the Cubist-inspired, two-dimensional woman's body to the right of the apparatus, a cardboard figure propped up by crutches. The latter is flirtatious and sensual, but her two-dimensionality makes her "unreal" (and therefore not threatening to one fearful of sexual relations with women). These figures are part of a physically

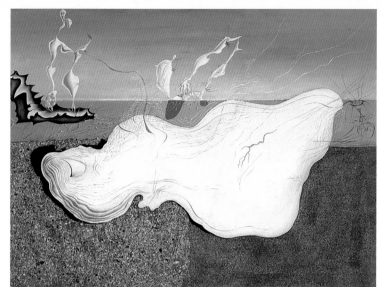

The Bather
1928
Oil on panel
20 ½ x 28 ¼"
(52.1 x 71.8 cm)

disjointed world in which Dalí has not yet succeeded in evoking the surreal world of his later paintings.

- **FANTASY LANDSCAPE:** Elements familiar to the child in Dalí, such as the rock formations in the background and the sea, are reminiscent of Cadaqués.

- **ROTTING DONKEY AND FISH:** These are symbols of the *putrefacto*, or rotting, conventional thought of the bourgeoisie.

It is clear from the painting that Dalí is moving toward Surrealism and

has begun to select symbols from the dream world—a process that will become central to his paranoiac-critical method of painting.

Paintings from 1928 reflect his ongoing experiments with form, especially with the human body as the link between the conscious and unconscious worlds. Distorting the body in a variety of abstract ways, with strange amoebic shapes, as in *The Bather,* is an attempt to focus on the primal aspects of genitals, phallic fingers (here, a thumb complete with nail), and memories from his childhood. (Dalí later writes that this painting depicts his sighting of a beached whale when he was a child.)

Philosophical and Artistic Differences with Lorca

While Lorca and Dalí remain close, their artistic visions are now dramatically at odds. Dalí finds Lorca too traditional, not driven enough to forge new ground in poetry. He wants Lorca to write about 20th-century inventions like automobiles, planes, and American jazz—not about gypsies romantically strumming guitars in the hills of Spain. This, coupled with Dalí's feelings of suffocation as the object of Lorca's desires, causes their friendship to cool.

Nietzsche's influence

During this key moment in his career, Dalí reads Friedrich Nietzsche, the German philosopher who questions the moral, philosophical, and religious foundations of Western society. Known for his famous

proclamation "God is dead," Nietzsche has been (wrongly) attacked as an advocate of brute amorality and for writings that contain roots of Nazi ideology. Dalí is intoxicated by Nietzsche's attacks on society's cherished beliefs, especially his disavowal of the notion of progress: As a prophet of modernity, Nietzsche rejects the idea that one generation builds upon the progress of the previous generation. For Nietzsche, life is experiential and fleeting; it is experienced uniquely by everyone, and when it is over, that's it! The moment is gone forever. This is a central feature of *performance art:* It speaks to one particular moment in time, then it's finished. **Dalí instinctively grasps the modern quality of performance art and of his own sense of showmanship,** and Nietzche's thinking supports his instincts.

Return to Paris: Surrealism!

In 1929, Dalí persuades his father to pay for a second trip to Paris. This time he goes alone. His friend Buñuel, eager to break into the film business, has already moved to Paris. During the winter, they had worked in Figueras on their film script for *Un Chien andalou* ("An Andalusian Dog"). But upon his arrival in Paris, Dalí seems more interested in meeting the key members of the Surrealists than in making movies. He takes lodgings in Montmartre, the artists' quarter, and savors some of Paris's infamous brothels. He visits the studio of fellow Catalan painter, Joan Miró, who is by now an established artist and who introduces Dalí to the vibrant art world in Paris.

Joan Miró joined the Surrealist movement in 1924 after making a name for himself in the avant-garde artistic circles in Barcelona. His aquaintance of Picasso eased his transition into Paris. His early paintings were so precise in their imagery that they took on an almost hallucinogenic quality. The Surrealists encouraged him to rely on his dreams and imagination.

Un Chien andalou

For Dalí, working on *Un Chien andalou* soon becomes his most important activity in Paris—even more so than accompanying Miró on his many social outings. Buñuel is ready to begin production and shooting takes a mere two weeks. Buñuel later claims that "nothing in the film symbolizes anything," but the images of donkeys rotting on pianos ("putrefactos") suggest that Buñuel and Dalí are playing out old themes from their days at the Resi. The title of the film is the same as one of Lorca's poems—a fact that Lorca considers to be a personal attack.

Audiences are shocked by the film, which is what Dalí and Buñuel have been hoping for: They want to "carry each member of the audience back to the secret depths of adolescence, to the sources of dreams, destiny, and the secret of life and death." Its most notorious scene, in which a knife slices a girl's eye (they actually used an ox's eye), is among the most memorable and horrific in film history. Moments after the film's premiere, Breton proclaims it "the first Surrealist film."

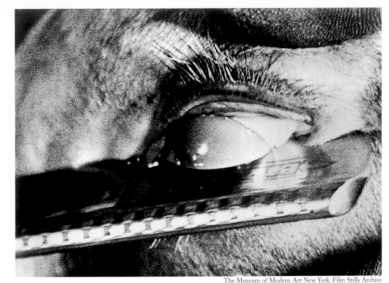

The Museum of Modern Art New York. Film Stills Archive

Meeting the Poet Paul Eluard

Though lonely and feeling isolated, Dalí remains in Paris for the early part of the summer of 1929. One night, the art dealer **Camille Goemans**, pitying Dalí, takes him to a fashionable club, where he introduces Dalí to the well-known Surrealist poet Paul Eluard. (Goemans is the dealer for most of the Surrealists, including Dalí, until his gallery closes in 1931.) Dalí and Eluard get along famously and finish the night with a promise to rendezvous in Cadaqués later in the summer.

Obsession with Masturbation and Impotence

Prior to the summer of 1929, Dalí's sexual obsessions in his paintings have centered on self-masturbation. He has never had a fulfilling sexual relationship with a woman and is tormented by the specter of impotence that such a relationship might induce.

In the summer of 1929, Eluard heads to Cadaqués with Gala, his wife, accompanied by the artist **René Magritte** (1898–1967), his wife Georgette, and Camille Goemans. Dalí has been working nonstop on his major new work, *Dismal Sport* (1929), and is feeling near madness when the party arrives. Gala, however, changes all that: The two are instantly smitten with each other.

Gala Leaves Eluard for Dalí

When her husband and the others return to Paris baffled but excited by *Dismal Sport*, Gala stays on with Dalí in Cadaqués. He later claims that Gala helped rid him of many sexual hang-ups and fears. Under Gala's watchful eye, Dalí feels "safe" and ready to pursue his career. His paintings now open up to new kinds of symbolism.

BACKTRACK:
GALA ELUARD DALÍ

Helena Deluvina Diakonoff was born in Russia around 1894. She took the name Gala early in life. One of four children, she was raised by her mother and her mother's companion, a wealthy Jewish lawyer. Restless from an early age, Gala was both charmingly seductive and mercilessly cold. She moved to Paris and married the poet Paul Eluard in 1917. The two were well known for seeking third partners, usually male, for *ménages à trois*. In later life, Gala developed a reputation for being secretive and unreliable about her past.

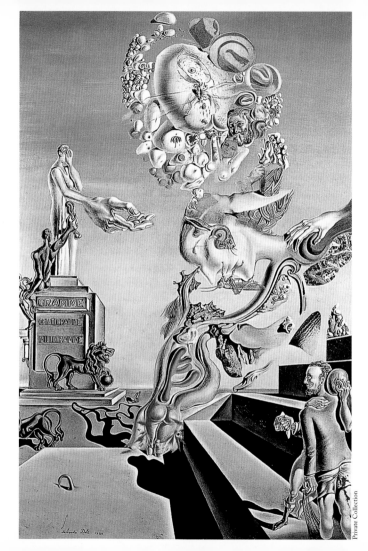

The year 1929 is a turning point for Dalí—the year of his most explosive canvases. At the beginning of the year, he feels claustrophobic about his art and life. *Dismal Sport* (also known as *The Lugubrious Game*) is a strong example of this phase. By year's end, his work expresses a newly discovered sexual liberation. *The Enigma of Desire* and *The Great Masturbator* reveal his post-Gala feelings of liberation.

Despite his wariness of the Surrealists' focus on automatism, **Dalí officially joins the movement in the summer of 1929** when he sees that there is room for novel approaches such as his own. *Dismal Sport,* included in his one-man show at Goemans's gallery in November 1929, announces his "arrival" as a Surrealist. Breton writes enthusiastically about it in the preface to the exhibition catalogue. Dalí calls it "a terror picture" because of its theme of castration.

When you look at *Dismal Sport* for the first time, you might be tempted to ask, "What gives???" But each detail contributes to the painting's "dream" statement that masturbation is dirty and causes guilt—which leads to parental disapproval, followed by castration.

OPPOSITE
*Dismal Sport
(The Lugubrious
Game).* 1929
Oil and collage
on cardboard
17 1/2 x 11 15/16"
(44.45 x 30.32 cm)

Sound Byte:

"The fact that I, myself, do not understand the meaning of my paintings at the time that I am painting them does not mean that they have no meaning."

—DALI, January 11, 1935, in a lecture at
The Museum of Modern Art, New York

- **The sexual nature** of the painting is quickly established with the sleeping head of Dalí, touched from behind by a woman's hand.

- **A grasshopper,** symbol of terror from Dalí's childhood, is fastened to the artist's face. (Dalí recounts in *The Secret Life* that he had loved grasshoppers as a child until one day, after catching an extremely ugly fish and looking closely at its face, he found that it resembled a grasshopper. From that moment on, Dalí feared grasshoppers.)

- **The dreamer** is suspended above a mounting staircase; in Freudian theory, staircases represent a fear of intercourse, and the melting candle in the foreground symbolizes impotence.

- **The muscular naked man** at the base of the statue masturbates the androgynous statue (who has breasts, as well as a penis and an enormous hand, and who covers her/his face in shame).

- **The threat of emasculation** from a father figure (depicted above in the swirl of objects emanating from the dreamer's head) is formalized in the bloody hand of the figure grasping the bearded man on the lower right as well as in the bloody decapitated figure beneath the dreamer.

- **The bearded man's excrement-stained shorts** cause great furor among viewers. But Dalí argues that excrement fantasies are a natural part of repressed infantile material and that censoring destroys the dream's power.

- **The lions** symbolize animal aggression.

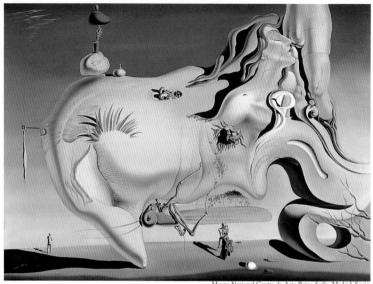

*The Great
Masturbator*
1929
43 ³/₈ x 59 ¹/₄"
(110.2 x 150.5 cm)

Dalí studies psychology textbooks to gain material for his paintings. This work shows his skill in pairing the "hallucinations" from his mind with the theoretical details from the textbooks.

The Great Masturbator, painted after Gala leaves Cadaqués, draws on similar sexual themes. Dalí refers to it as "the expression of my hetero-sexual anxiety." The sleeping Dalí head is present again, clenched by the dreaded grasshopper. The bleeding knees of the man being masturbated by a voluptuous woman suggest castration, and the fish hook lodged in Dalí's head emphasizes his anxiety in being trapped in this situation.

The text repeated throughout the image reads: *ma mère*

The Enigma of Desire, also from the late summer of 1929, isolates a winged phallus, symbol of male sexual desire, as an extension of yet another representation of the sleeping artist's head. The winged elongation extending from Dalí's head is designed to recall the rock structures at Cadaqués, with holes of erosion from the wind and water, and inscriptions to the artist's mother written several times inside the rock's cavities. On the left, Dalí is shown embracing a condensed group of favorite symbols, all relating to sexual desire and repression: the grasshopper, a fish, his father, an African lion, a woman with long hair, and a massive knife (phallic symbol) held by a severed hand.

OPPOSITE
*The Enigma
of Desire:
My Mother,
My Mother,
My Mother*
1929. 43 ¼ x 59"
(110 x 150 cm)

From Mother to Father

Similar impulses of desire and guilt are evoked in *The Profanation of the Host* of 1929, where a lecherous father figure in the shadows below faces a growling lion's head. In the brighter section above, we see the progressive disintegration of the artist's head as he swallows the Communion wafer and wine and comes under the control of the ever-dreaded grasshopper. This work profiles the guilt experienced by a Roman Catholic sinner who profanes the host by choosing to receive Holy Communion. In 1945, U.S. Customs labeled this painting "obscene."

Each of these works of art shocked the general public in the 1930s, given that sexual subjects were considered taboo. Masturbation—

which Dalí practiced and alluded to in his paintings with great frequency—was widely considered a sin against nature. People were offended that such "filth" could be called art. Dalí, however, cared little for their opinion; he was already well on his way to becoming the most famous and notorious member of the Surrealists.

Dalí's tendency to provoke, shock, and insult is limitless. During that summer in Cadaqués, he inscribes one of the paintings that he is preparing for his first one-man show at Goemans's gallery with, "Sometimes I spit for pleasure on the portrait of my mother." He does not mean it literally, but rather as an expression of paranoiac-critical material, reflecting the infantile, untamed nature of the unconscious. But when his father (who dislikes Gala) hears about this "insult" to his dead wife, he banishes his son from the family—just the impetus Dalí needs to move back to Paris with Gala to make his mark on the art world. Dalí and his father will not see each other again until 1948.

OPPOSITE
Profanation of the Host. 1929
39 ³/₈ x 28 ³/₄"
(100 x 73 cm)

Sound Byte:
"People were glued in front of my pictures.... The poetic fact held them, moved them subconsciously, despite the violent protests from their culture and their intellect."

—Dali

Return to Paris and a Surreal Welcome

In Paris, Dalí surrounds himself with friends from the Surrealist group. He joins Gala, who has now left Eluard. Breton welcomes Dalí's raw energy and originality and is particularly intrigued by his paranoiac-critical philosophy of art, which Dalí outlines as a manifesto in a 1930 article *L'Ane pourri* ("The Rotting Donkey").

Financially, times are tough for Dalí. His paintings are considered too scandalous to sell. But Gala urges her art-dealer friends to push her lover's work. She has quickly become Dalí 's live-in agent, carefully monitoring his career and finances.

Paris is not only expensive, it is distracting. By 1930, Dalí wants to leave for Spain to paint in solitude, but Gala persuades him to stay on and establish himself in the Paris art world. He collaborates with Buñuel on his next film, *L'Age d'or*, which provokes rage among the right-wing fascists, who raid the theater in protest.

Gala's insistence that they remain in Paris proves beneficial, since, before long, Dalí is invited to the mansion of the **Viscount Charles de Noailles** (1891–1981) and his wife, the **Vicountess Marie-Laure de Noailles** (1902–1970), who have recently purchased *Dismal Sport* from the Goemans exhibition. Paris's preeminent collectors of avant-garde art have now taken an interest in Dalí 's career.

An important Sale

Dalí's connection to the Viscount proves fortuitous. In 1931, when Goemans goes bankrupt, the Viscount offers Dalí financial support. Dalí's first painting for the couple is *The Old Age of William Tell* (1931), for which he is paid a handsome 29,000 francs. Dalí choses Tell as an archetypal father figure, with the famous legend of the father shooting an apple off his son's head representing the castration myth, a common theme in his paintings of this period.

The sale of this piece gives Dalí the financial wherewithal to return to Spain. Still banished from his family home in Figueras, **Dalí buys a tiny shack in Port Lligat,** a little fishing village two kilometers from Cadaqués. Until his death, he and Gala share this house, adding rooms over the years as their penchant for luxury increases.

It is during this first summer in Port Lligat that Dalí creates the monumental painting that will forever secure his reputation as a great 20th-century artist and iconographer: *The Persistence of Memory.*

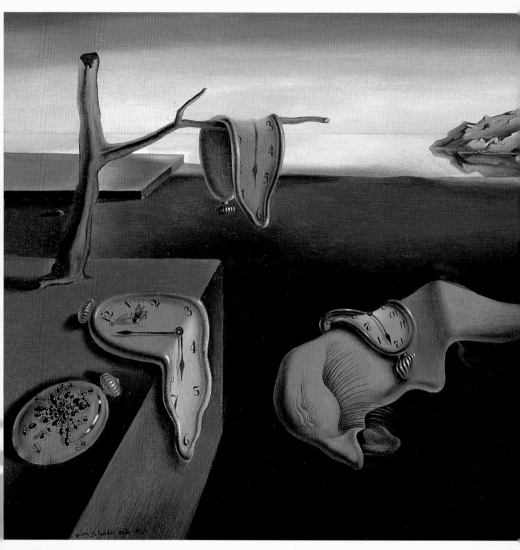

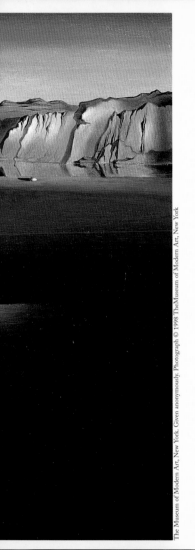

THE PERSISTENCE OF MEMORY (1931)

9 ½ x 13" (24.1 x 33 cm)

With *The Persistence of Memory*, Dalí reaches his maturity as a Surrealist painter. Also known as *Soft Watches*, the lean, richly colorful, well-constructed (and small! it's only 9 ½ x 13") painting depicts carefully chosen unconscious material that crystallizes Dalí's paranoiac-critical method: The three melting watches symbolize the innate lack of meaning or reliability of the non-dreaming, conscious world. One of them droops over the branch of a dead olive tree, another over a block of stone, and the third over a sleeping, amoebalike head that is the painter himself—it's the same head as in *Dismal Sport* and *The Great Masturbator*. Each watch tells a different time; their power in the conscious world vanishes in the dream state—a locus controlled by memory, not by linear time. We recall from Freud the **persistence** of our unconscious instincts seeking conscious expression. Since our past is preserved as **memory,** Dalí's message is that our unconscious mind is ever-vigilant, ever-present in our daily lives and exerts more power over us than any manmade object of the conscious world. In the Dalinian universe, soft objects are detestable: They are powerless and putrefying. Only hard objects, such as the rocks of Cadaqués in the background, have worth: Time has no power over them. (Wind and rain do, but not time.) A fourth timepiece—a closed gold pocket watch—is covered with ants, a Dalinian symbol of anxiety, apprehension, and putrefaction. They swarm over the timepiece as if it were discarded meat left to rot. (A portrait of Dalí's father done in 1920 features a similar pocket watch; this watch points to the decaying relationship with his father at this time.)

In early 1932, this painting was exhibited at the Julien Levy Gallery in New York as part of a retrospective, "Surrealist Paintings, Drawings, and Photographs" (January 9–29, 1932). It introduced Dalí and Surrealism to America.

Phalluses, Crutches, William Tell: Authority Figures

Back in Europe, Dalí's right-leaning sympathies, as expressed in his paintings and opinions, provoke not only the anger of the general public, but also his Surrealist colleagues. Though Dalí maintains he is apolitical, his ideas are more in harmony with the right than the left.

Europe is cowering under the threat of fascism, and communism is felt to be the moral option to many, especially to artists and intellectuals. Lenin is their hero and father figure, regardless of his many questionable deeds. But Dalí, ever ambivalent about his own father, uses Lenin's image in mocking, less-than-flattering, "father-figure" ways, thereby angering other Surrealists. They are enraged by his portayal of Lenin in *The Enigma of William Tell,* arguing that he has insulted the great leader of the Russian revolution.

- Breton tries to slash the painting when it is exhibited at the Salon des Indépendents on February 2, 1934, but it is hung too high.

- Having failed to destroy the painting, Breton, the "pope of Surrealism," calls Dalí to his apartment to explain himself to the upper echelons of the Surrealist group for his "counter-revolutionary acts, tending to the glory of Hitlerian Fascism."

- Dalí arrives, dressed in layers of clothing. He listens to the charges, then begins stripping off sweaters until he is naked, all the while

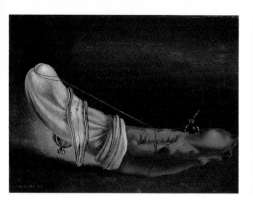

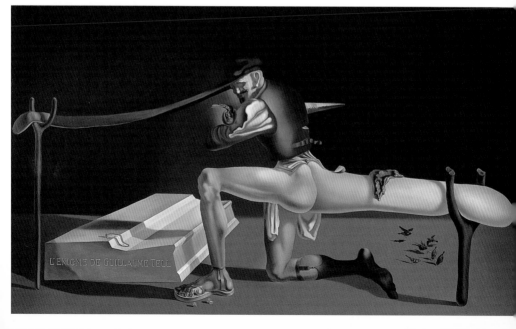

taking his own temperature, as if to demonstrate that he is not ill. Enjoying himself, he informs Breton that he has had a sexual dream about the latter. Breton is not amused, though others in the room laugh. Dalí is no Lenin-bashing fascist, but he has no patience for what he deems to be the humorless left-wing dogma of art-world communism. He wishes merely to counter it with a Surrealist gesture.

Breton calls for Dalí's expulsion from the Surrealists, but others vote not to expel him. They know he plays a crucial PR role in attracting attention to the movement.

Further mockery of Lenin is displayed in *The Enigma of William Tell,* part of a series of paintings named for the Swiss patriot. The face of the central figure, however, is that of Lenin, not of William Tell. Neither Tell's face nor his legend plays a role in the works. Only his name, which evokes father-figure images, has a purpose. Intent on ridiculing father figures, Dalí stretches Lenin's cap and buttocks to ridiculously phallic proportions and pierces Lenin's chest with a phallic spike. Phallic symbols, tiresome as they will become, occur frequently in Dalí's early 1930s paintings, a reflection (some say) of his ongoing preoccupation with impotence and (perhaps) his own sexuality. Here, Lenin's buttock is soiled with excrement and his phallic "manhood" is propped up by **crutches,** a Dalinian symbol of authority. (As a child, Dalí had discovered a crutch in the attic at the Pichots' estate and had felt so empowered by

Drawing of a crutch, from *The Secret Life of Salvador Dalí*

it, as a kind of "kingly sceptre," that he formed a fetishlike attraction to it and used it in his paintings whenever he wished to show power, authority, stability, or sexual prowess. In *The Secret Life,* in typical Dalinian hyperbole, he proclaimed the crutch to be "the symbol of death and the symbol of resurrection!")

Though Dalí distances himself from the Surrealists after this, he nonetheless continues to identify with the group. After all, he has made his reputation as a Surrealist and the movement has achieved worldwide recognition. To declare himself no longer a Surrealist makes no sense either commercially or philosophically.

The Zodiac to the Rescue

In 1933, Dalí has his first solo show at the same gallery. Reviews are more favorable than not. Still, finances remain a nagging problem. By 1933, Gala and Dalí are so short of funds that Gala approaches the socialite art collector **Prince Jean-Louis Faucigny-Lucinge** with a proposition: Will he assemble a group of twelve of Dalí's rich admirers to see if each would be willing to sponsor the couple for one month of

the year? They will be rewarded for their support with art. The Prince agrees to the plan and promptly begins his search for the other eleven. Soon **The Zodiac Group is born:** Twelve benefactors agree to "sponsor" Dalí one month of the year in exchange for one large and one small painting. While this guarantees Dalí an income, it means that he must work quickly to make art available to his investors. The latter include the writer Julien Green, the wealthy American collector Caresse Crosby, and Viscount de Noailles, among others. The arrangement continues until the beginning of World War II in 1939.

OPPOSITE
Galarina
1944-45
25 ¼ x 19 ¾"
(64.1 x 50.2 cm)

Dalí Marries Gala

In early 1934, Dalí and Gala are married in a no-frills civil ceremony. On the surface, Gala continues to satisfy Dalí's every need, though his friends wonder how he tolerates her frequent infidelities. (Over the years, Dalí watchers have suspected that their relationship may have been opportunistic, serving both of them well, especially if he was ambivalent about heterosexual sex.) Gala's liaisons continue throughout their marriage, including with her former husband, Paul Eluard.

On November 14, 1934, Dalí and Gala arrive for the first time in New York via a third-class steamer cabin paid for by Picasso. Dalí announces to the press that he is the only authentic member of the Surrealist movement, a remark that further outrages his colleagues in Paris. His show at the Julien Levy Gallery improves his financial

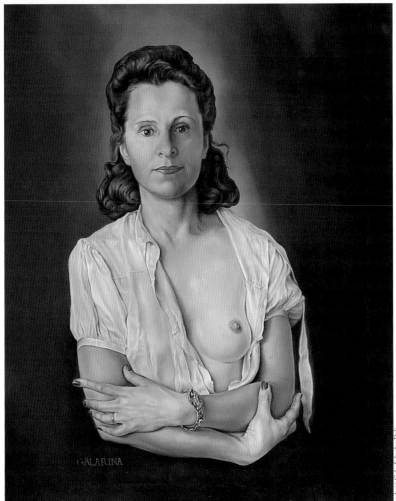

status, for the moment at least. Of course Dalí does anything but the practical with the money: He hosts a ball where everyone is required to come dressed as their favorite dream! In a moment of fun, he paints *The Face of Mae West (Usable as a Surrealist Apartment)* (p. 90), a glimpse of the lighter "Surrealist Objects" to come. Later in 1935, Dalí is formally expelled from the Surrealists mostly for political reasons; but since he has wealthy patrons and a growing international reputation, he pays little mind to the expulsion and, for the rest of his life, "sells" himself as a Surrealist.

One of Dalí's stranger paintings from this year is *Archaeological Reminiscence of Millet's "Angelus,"* inspired by Millet's 1859 painting, *The Angelus.* Dalí has long been fascinated by the rural piety of this painting and believes that its popularity stems from its underlying theme of castration of the husband and the killing of the son. (There is no son in the painting, but Dalí claims that an X-ray of the work would reveal a coffin beneath the spot where the basket now stands.) **Dalí uses his version of Millet's painting to illustrate his paranoiac-critical method,** in which artists can work through their obsessions by selecting and organizing symbols on the canvas (or the page). Dalí's painting features the unusual mating ritual of the praying mantis, in which the female kills and eats the male after copulation. Note that the male figure on the left tries to protect his genitals from the female, attended by cypress trees, symbols of death. The theme of sexual tension is revisited in the same year in *Woman with a Head of Roses* (p. 9).

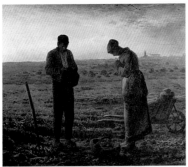

Musée d'Orsay, Paris, France. Scala/Art Resource, NY

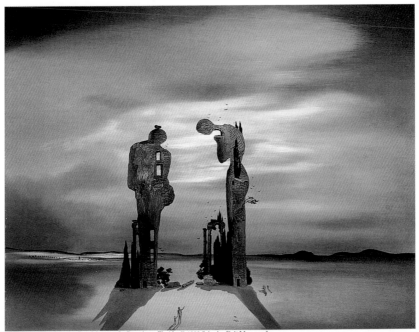

Collection of The Salvador Dalí Museum, St. Petersburg, Florida. © 1998 Salvador Dalí Museum, Inc.

Dalí enters Café Society

Dalí begins to travel with the smart set and is fascinated by the super-rich. Tycoons and aristocrats from around the world make Paris their home, and the Dalís are often invited to their dinner parties and weekend getaways. He envies their ease and genteel eccentricities, while they find in Dalí a constant source of entertainment.

One of these millionaires is the Englishman **Edward F. W. James** (1907–1984), godson of King Edward VII, whose collection of Surrealist paintings and sculpture is among the best in the world. For two years (1936–38), James quickly becomes one of Dalí's most important patrons, providing him with a generous monthly paycheck in exchange for the right to buy any of his works—paintings, drawings, or other objects.

Dalí now begins to make a sensation among the wider art-viewing public. At the International Surrealist Exhibition in London on July 1, 1936, he gives a lecture wearing lead boots and a deep-sea diving suit (to symbolize his dive into the unconscious) and nearly suffocates to death. The public and press take notice.

Sound Byte:

"The difference between a madman and me is that I am not mad."

—DALI, December 18, 1934, in a lecture at the
Wadsworth Atheneum, Hartford, Connecticut

Dalí and the Spanish Civil War

The Spanish Civil war breaks out in 1936 and lasts until 1939. It is a bloody contest between left-leaning democratic "Republicans" and the right-wing fascists, led by **General Francisco Franco** (1892–1975). The sympathies of most European and American artists and writers are on the side of the Republicans. Many, including the writers **George Orwell** (1903–1950) and **Ernest Hemingway** (1899–1961), travel to Spain in support of the cause. Dalí, however, barely involves himself: He and Gala leave for Paris, and after their departure their house at Lligat is destroyed.

In 1937, sensing trouble in Paris, Dalí and Gala flee to Italy to stay with Edward James and the fashion designer, **Coco Chanel** (1883–1971). There, he visits museums and rediscovers the art of the Italian Renaissance. During this time he creates commercial illustrations and advertisements for American magazines such as *Harper's Bazaar* and *Town and Country*.

Ultimately the fascists win and a dictatorship is established under Franco, whom Dalí supports later in life. Dalí's political views and opportunism have often tainted his art in the minds of critics, but two paintings from the period suggest that his response to the ravages of the Spanish Civil War was not as callous as assumed: *Autumn Cannibalism* and *Soft Construction with Boiled Beans: Premonition of Civil War,* both painted in 1936.

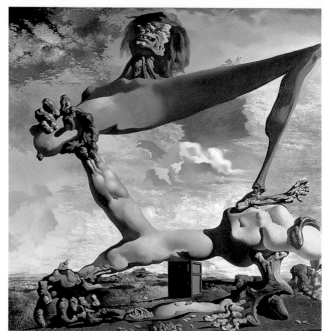

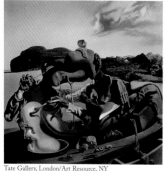

Tate Gallery, London/Art Resource, NY

Philadelphia Museum of Art: The Louise and Walter Arensberg Collection

In *Autumn Cannibalism,* the entwined couple that dominates the painting is a graphic representation of cannibalism and civil war. Two figures scoop the flesh of the other with knife and spoon as they embrace: a sexually violent personification of a country at war with itself. The finery of the couple reminds us of Dalí's hatred of the *putrefacto* for whom sex, eating, and destruction are interchangeable

68

activities. The tongue in the foreground is spiked by a nail, symbolizing an inability to communicate or protest. The drawer symbolizes sexual desire and memory for Dalí, who implies that what ensues when desire is released is not only sex, but the grotesque violence of two people consuming each other.

With the gnarled head and hands of the figure at the center of *Soft Construction with Boiled Beans,* Dalí makes the point that the impending Spanish Civil War will be a calamity of tragic, cannibalistic destruction. The parched landscape and tumultuous sky are ominous signs of deprivation and disaster. Boiled beans depict poverty and wartime scarcity.

New Techniques: Double Images and Drawers

Two of Dalí's favorite techniques from this period are his use of **drawers** (a form of Freudian *displacement*) and **double images** (Freudian *condensation*):

OPPOSITE

LEFT
Autumn Cannibalism
1936. 25 ⅝ x 24 ⅝"
(65.1 x 62.5 cm)

RIGHT
Soft Construction with Boiled Beans (Premonition of War)
1936
39 ⁵/₁₆ x 39 ⅜"
(99.9 x 100.0 cm)

- **Drawers** that pull out from human bodies, transforming them into furniture pieces, become architectural metaphors of memory and of the unconscious mind: Dalí uses drawers as symbols onto which he can transfer unrelated impulses and make them graphically clear to the viewer. Good examples of this technique can be seen in *Spain* (1936–38) and *The Burning Giraffe* (1936–37). The woman leaning on the night stand in *Spain* represents the Spanish Civil War; the bloody scarf dangling from the top drawer symbolizes the ravages of war.

- **Double images,** or *trompes l'oeil* (optical illusions), are pictorial riddles that invite the viewer to look at the painting in different ways. To use Freudian lingo, Dalí condenses two or more unrelated figures into one symbol or cluster of symbols, and depending on how you look at the painting, these figures come in and out of focus, replacing one another simultaneously.

In *Spain,* look for the woman's face; it's part of the double image formed by people engaged in violent combat. Her breasts emerge as part of the double image formed by the two knights dueling with lances. This technique is brilliantly illustrated in *The Metamorphosis of Narcissus* (pp. 74–75) and can also be seen in *The Great Pananoiac* (where citizens from Ampurdán collectively form a man's face), *Apparition of Face and Fruit Dish on a Beach* (a pleasing but less intricate form of this technique), and *Slave Market with the*

OPPOSITE
The Burning Giraffe
c. 1936–37
Oil on wood
13 3/4 x 10 5/8"
(35 x 27 cm)

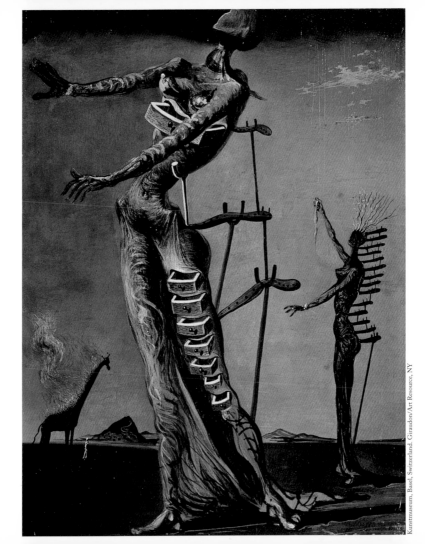

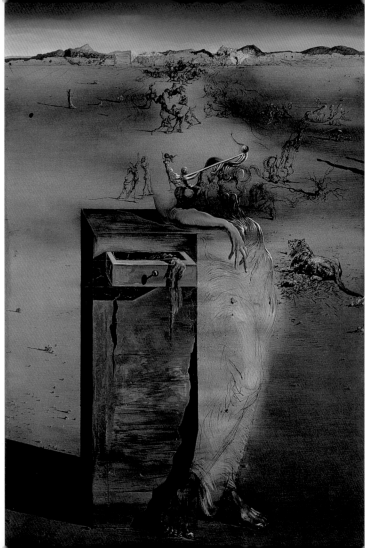

Disappearing Bust of Voltaire—a marvelously inventive pairing of women in 17th-century Spanish costumes who emerge as the face of the skeptical philosopher, Voltaire, who stares at the semi-nude Gala, who protects Dalí from the "slave market" of the outside world and skeptical people like Voltaire.

The use of double images becomes the keystone of Dalí's future aesthetic: While painting, Dalí identifies an image he created the day before and continues working on this hallucinatory work. But after an image becomes too familiar, it gradually "loses its emotive interest and instantaneously becomes metamorphosed into 'something else,' so that the same formal pretext lends itself…to being interpreted successively by the most diverse and contradictory configurations."

OPPOSITE
Spain. 1938
36 ⅛ x 23 ¹¹⁄₁₆"
(91.8 x 60.2 cm)

The Metamorphosis of Narcissus is a fine example of the narcissism of Dalí's paranoiac-critical approach, in which a viewer sees double images depending on his/her "degree of paranoia" or ability to organize unconscious material produced by dreams. In the myth that inspired this painting, Narcissus is in love with a reflection of himself in the water and drowns while trying to reach it. Here, a pair of "double

Sound Byte:

"The human body…is full of secret drawers that can only be opened by psychoanalysis."

—DALI

73

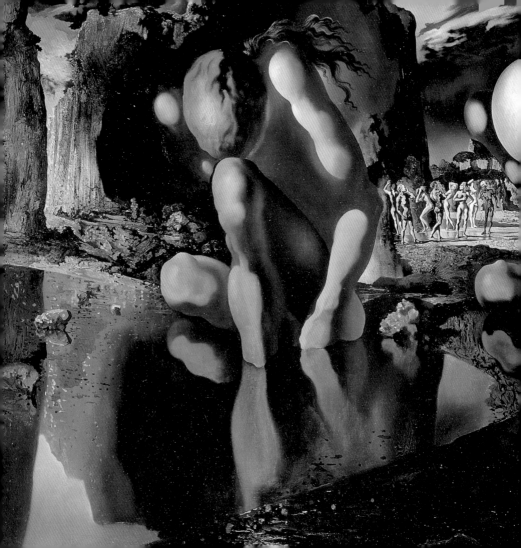

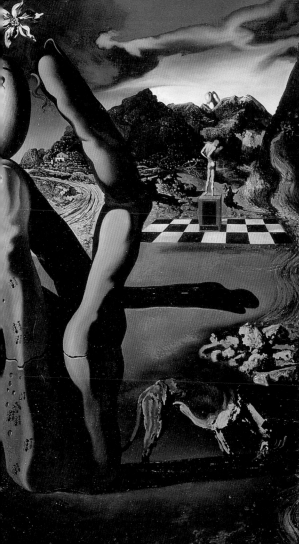

*Metamorphosis
of Narcissus*
1937
20 x 30"
(50.8 x 76.2 cm)

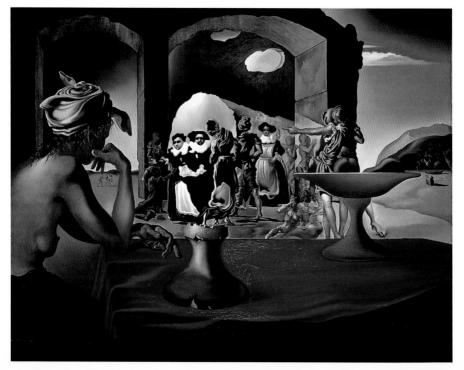

images" dominates the painting. On the left, we see a strange rock formation that "doubles" for the seated, bent-over Narcissus gazing into the water. His walnutlike head contains the outline of a human figure. On the right, we see a hand that may be dead (or it may be stone) that echoes the shape of Narcissus's crouched body. This stony hand rises from the ground and delicately holds a cracked egg, which sprouts a narcissus flower. The crack in the egg has the same human outline as the mark on Narcissus's head. Each image—the egg, the head, the hand—has multiple meanings that lead the viewer to ponder the connections linking these pieces. These mysterious links destabilize each other and call into question the supposedly "fixed" identities of each.

Two other works from this period are *Lobster Telephone* (p. 90) and *Sleep* (p. 81). The former, one of Dalí's famous Surrealist Objects, is

> **FYI: Dalí meets Freud**—Austrian-born writer Stefan Zweig (1881–1942), a friend, arranged for Dalí to meet Freud at his home in London on July 19, 1938. Freud was not impressed, and it was Dalí's only visit with Freud, who later announced that he found the flamboyant Dalí to be one of the biggest fanatics he'd ever met. Not long after this visit, in which Dalí found himself essentially rejected by his lifetime idol, the painter began to move away from Freudian theory in search of other ways of expressing his obsessions, embracing, for example, Catholicism and, after the atom bombs of World War II, nuclear physics.

OPPOSITE

TOP LEFT
The Great Paranoiac
1936
Oil on panel
24 3/8 x 24 3/8"
(62 x 62 cm)

TOP RIGHT
Apparition of Face and Fruit Dish on a Beach
1938. 45 x 56 5/8"
(114.3 x 143.8 cm)

BOTTOM
Slave Market with the Disappearing Bust of Voltaire
1940
18 1/4 x 25 3/8"
(46.4 x 64.5 cm)

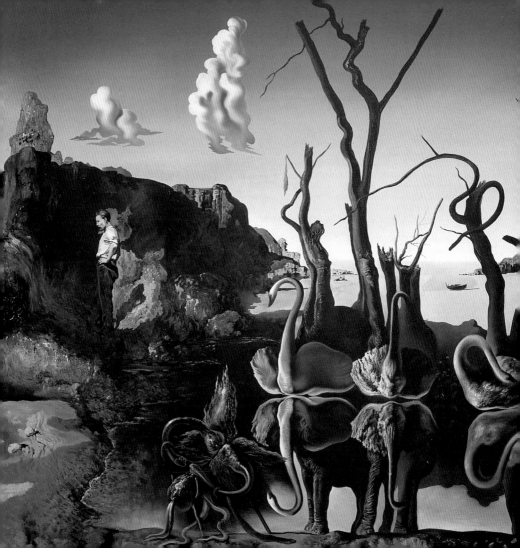

*Swans Reflecting
Elephants*
1937
20 ¹/₁₆ x 30 ³/₈"
(51 x 77 cm)

created with the purpose of allowing people to "touch their dreams." The latter, *Sleep* (on the jacket of this book), represents the dominance of the sleeping world (propped up by 11 crutches) over the real world. Dalí writes that this painting expresses "with maximum intensity the anguish induced by empty space."

Dalí Intrigued by Hitler, Breaks with the Surrealists

In an essay that many find morally repulsive, Dalí writes that the phenomenon of Hitler is interesting, even attractive, from a Surrealist point of view. (Speaking with a biographer when he was old, Dalí says, "To me, Hitler embodied the perfect image of the great masochist who would unleash a world war solely for the pleasure of losing…. That should indeed have warranted the admiration of the Surrealists.")

Though **Dalí denies having sympathies for Hitler,** the left-wing avant-garde of the 1930s will tolerate nothing less than virulent denunciations of Der Führer and his murdering conspirators. Dalí's friends believe the incident is yet another attempt at provocation, but the Surrealists, André Breton chief among them, are not amused. It is after Dalí publishes his essay that they formally expel him from their inner circle. With the publication of his essay, he forever sheds communism and all formal association with the movement of Surrealism.

In 1937, after returning to Paris, he works with the famous fashion designer **Elsa Schiaparelli** (1890–1973) on Surrealist-inspired

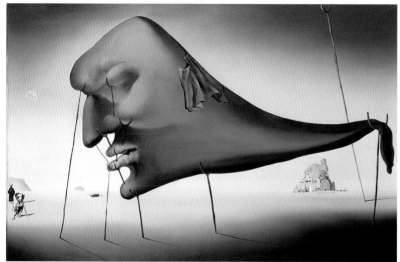

Sleep. 1937
20 ⅛ x 30 ¾"
(51.1 x 78.1 cm)

couture. In his never-ending quest for money-making ventures, Dalí branches out into designing Surrealistic store display windows at exclusive establishments like Bonwit-Teller in New York.

Radical Changes

By 1940, World War II is in full tilt. The Germans goose-step into Paris and take control of France, boasting the official Nazi policy that modern art is "degenerate." Artists, many of them Jewish and communist, fear not only for their art, but for their lives.

It is a dark period for Dalí, and this darkness is reflected in paintings such as *Daddy Longlegs of the Evening–Hope!* and *The Face of War*. Not only has the Spanish Civil War forced Dalí to leave behind his cultural heritage, but World War II now forces him to abandon his adopted home of France. This, coupled with the disinterest of his hero, Sigmund Freud, leads Dalí to a low point in his life. It is time to reassess both his life and his art.

Daddy Longlegs of the Evening–Hope! is a depressing, haunting, work that trumpets the evils and carnage of war. In the bottom left corner, a small cherub covers its weeping eyes to hide from the atrocities of war and the destruction of art and beauty: The ravaged artist (Dalí himself), with a lifeless cello and unused ink wells (representing the music and literary worlds), droops across a barren tree branch, his face crawling with ants (putrefaction) and his body a melted object similar to the watches in *The Persistence of Memory*. Note that Dalí has given this figure breasts. The shadows from the daddy-longlegs spider, however, form the outline of a flower and thereby convey a sign of hope that the brutal war will end soon. Dalí calls this painting "a type of waking nightmare." It is one of his finest representations of psychological confusion, horror, and impending tragedy.

The Face of War, a graphically strong and less confusing work than Dalí's other Surrealistic paintings, is an unambiguous depiction of war as death, pain, and horror. Dalí's goal is to create an arresting

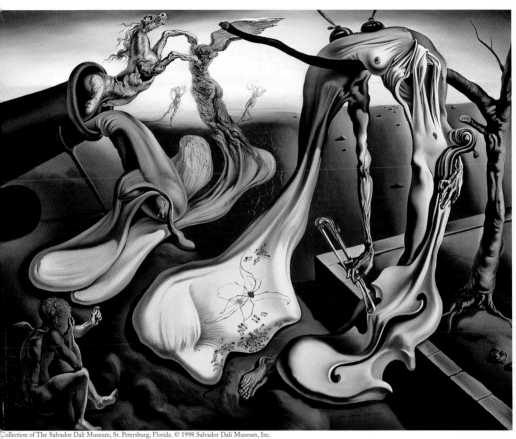

image to stop people in their tracks at the contemplation of war's atrocities. Dalí remarks that the eyes in this painting are "stuffed with infinite death."

Southern Hospitality

Once the Dalís reach America on August 16, 1940, their first stop is Hampton Manor, the Fredericksburg, Virginia estate of their Zodiac supporter, Caresse Crosby. After a quick trip to Pebble Beach, California, they return to New York, where they stay at the posh St. Regis Hotel, a short walk from The Museum of Modern Art.

"Growing" the Image

Dalí's American years are primarily devoted to further manufacturing his outrageous public persona. Truth is, his important work occurred in the 1920s and 1930s, and from this moment on he spends the rest of his life seeking ways to exploit his reputation, acquire wealth, and play the role of Salvador Dalí. Though several beautiful, well-known works of art are indeed created during the post-war period, there are few artistic innovations.

Plunging into the American lifestyle, Dalí pays homage to American culinary tastes by inserting a strip of bacon into his *Soft Self-Portrait with Grilled Bacon*. The requisite ants and crutches are there too, repeating the oft-expressed symbols of his Surrealist days: "Instead of

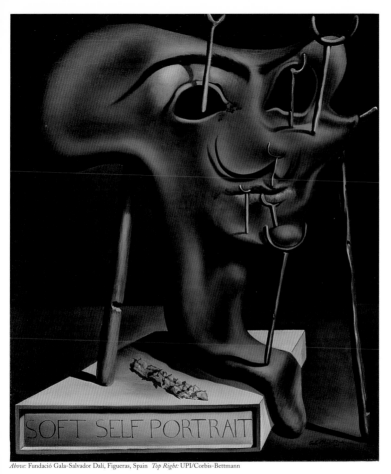

painting the soul—the inside—I wanted to paint solely the outside, the envelope." However, there is nothing new.

He receives his first museum retrospective, at The Museum of Modern Art in New York, from November 19, 1941 until January 11, 1942. The show is a huge success and Dalí seems to be off and running in America. He aggressively pursues new directions and rebirth in his art, moving beyond the "tried and true" results of Surrealism. This change can be seen, symbolically, in *Geopoliticus Child Watching the Birth of the New Man,* a more classical and philosophical work than his previous paintings. At the bottom right, a withered figure representing the Old World and its tired traditions points out to a curious child the "new world" (post-World War II) emerging from the North American continent on the egg-shaped globe. This painting, free of the condensed (and often obscure) symbolism of the paranoiac-critical period, shows Dalí moving in the direction of a more representational, classical style.

OPPOSITE
Geopoliticus Child Watching the Birth of the New Man. 1943
18 x 20 ½"
(45.7 x 52.1 cm)

Dalí's Love of America

Dalí finds himself much in demand as the art world's expert on the unconscious. He does work for advertising firms and Hollywood studios (he composes the dream sequence for Hitchcock's *Spellbound* and works on the never-released Disney film, *Destino*). Dalí's many commercial activites during this period are frowned upon by art critics

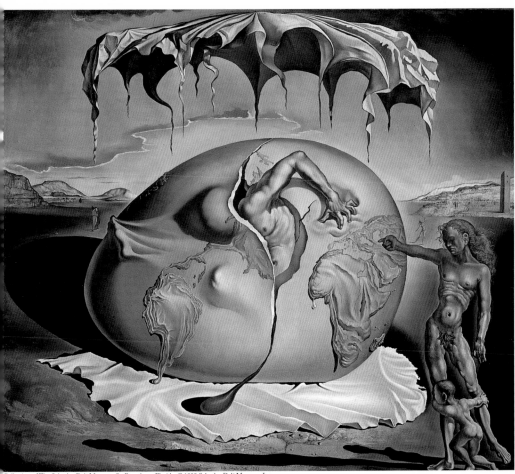

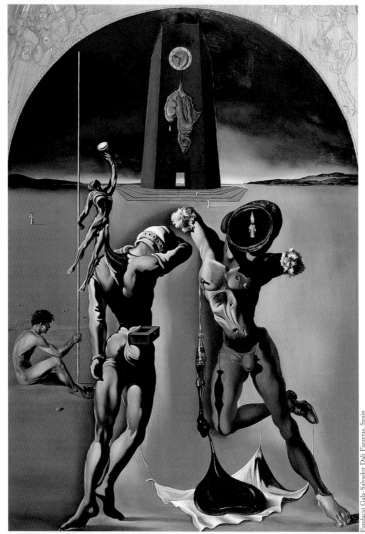

as too far removed from the realm of "high art." Dalí, of course, cares nothing about such opinions. He has his mind on other things, such as the tensions he sees around him in America between black and white people and that he feels will intensify after the war. In an under-appreciated work created in a hotel room at the Del Monte Lodge in Pebble Beach, California, Dalí paints *The Poetry of America (Unfinished)*, one of his finest postwar pieces that spotlights one of America's most urgent cultural crises.

OPPOSITE
The Poetry of America (Unfinished)
1943. 46 x 31"
(116.8 x 78.7 cm)

In this simple, unusually sensual work, the setting combines locales from Dalí's childhood (plains of Ampurdán, the Pichots' mill tower, the rolling rocks of Cadaqués), but the drama is American:

- **Two male football players,** one black (on the left) and the other white, in their 1940s helmets, engage in the struggle of a football match (through *displacement,* Dalí uses football uniforms to create a context that will be familiar to Americans).

- **The white man's head is empty,** his body filled with cotton; a putrid, morbid substance (the spilled blood of African Americans?) oozes from a Coca-Cola bottle that dangles from his nipple.

- **His African American rival,** a magnificently muscled athlete, gives birth not to a cloying soft drink, but to the new humanity, the hope for the future, on whose finger balances the "egg" of the new order.

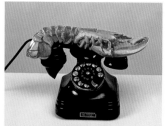

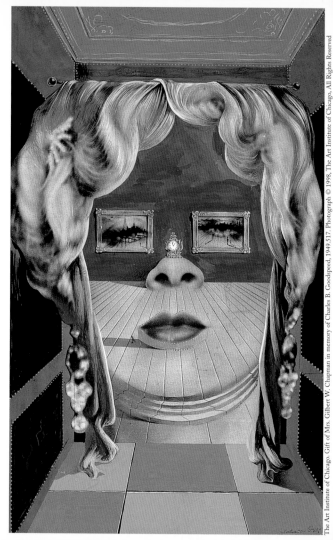

In the background, the skin of Africa, in the form of a map, hangs from the clock on the mill tower, as if time is running out on this struggle between the races. A naked (white) adolescent seems unaware of the conflict. This insightful painting was created years before Rosa Parks and Dr. Martin Luther King, Jr. and....

Fame and Hype

Dalí enjoys everything about America that is distinctly non-European, and in 1942 publishes his "autobiographical" *The Secret Life of Salvador Dalí,* an entertaining account of his own brilliance from infancy onward. Though he is moving away from Surrealism, he still creates works with a Surrealist tone—such as *One Second Before Awakening from a Dream Caused by the Flight of a Bumblebee Around a Pomegranate* (p. 4). Of greater interest, however, is the classical style to which he has returned, as in the Raphaelesque rendition of his wife in *Galarina* (p. 63).

During his time in America, Dalí's paintings become more comprehensible to the public, even if they are sometimes grand and operatic in scale. They reflect a **growing interest in Catholicism and in post-World War II science and physics,** and a discernible connection to real events, people, and figures from mythology and history. Even though he has been expelled from the Surrealist movement, Dalí becomes the face of Surrealism in America.

OPPOSITE LEFT
Lobster Telephone
1936. Mixed
Mediums
11 $^{13}/_{16}$ x 5 $^{7}/_{8}$ x 6 $^{11}/_{16}$"
(30 x 15 x 17 cm)

OPPOSITE RIGHT
The Face of Mae West (Usable as a Surrealist Apartment)
c. 1934
Gouache over photographic print, 11 $^{1}/_{8}$ x 7"
(28.3 x 17.8 cm)

While he is in California in 1947, he finds enough emotional distance from Europe to paint a stinging portrait of Picasso that mocks the latter's pursuit of ugliness and intellectualism in his paintings (p. 28). Dalí considers that he, unlike Picasso, pursues beauty and that this is the essential difference between the two painters. The painting sardonically stretches Picasso's brain out through his mouth, in the form of a spoon.

Return to Franco's Spain

Dalí misses Spain. After the collapse of Nazi Germany to the Allied Forces, the painter contemplates a return to Europe. He becomes unashamedly pro-Franco, even though Franco rules Spain with an iron grip and has estranged the country economically and culturally from the rest of Europe. Many in the art world find Dalí's pro-Franco stance immoral, but Dalí wants to return home and this is his way of doing it. In 1949, Dalí and Gala return to Port Lligat. Catalonia is ruined, but after sorting through the rubble, the couple sets about planning their new life, with Gala as grande dame of Port Lligat.

What *were* Dalí's Politics?

Throughout his life, Dalí's politics were fickle, contrarian, and self-serving:

- As a student in Madrid, he had supported Catalan independence, but as a young artist in Barcelona in 1928, Dalí renounced his Catalan pride to take on the mantle of modernism.

- To become modern—and to join the Surrealists—Dalí had at least to appear sympathetic with their communist leanings.

- But when he tired of their leftist politics, Dalí horrified the Surrealists by his "fascination" with Hitler.

- When Franco set up his dictatorship in Spain, Dalí rallied to his side at least in part because he wanted to insure that he would be able to return to live and work in peace in his native country. (Never mind that Franco's government had the blood of Lorca and many other of Dalí's compatriots on its hands.)

Catholicism, Mysticism...and Nuclear Physics!

Dalí and Gala spend the 1950s jet-setting between New York and Paris and their seaside home in Port Lligat, which they have rebuilt substantially since the war. Dalí designs extraordinary jewelry—small Surrealist sculptures in gold and precious stones—and paints less frequently. When he does paint, the images incorporate his new interests in Catholicism and nuclear physics, which have their origins in his profound shock over the atom bomb at Pearl Harbor on August 6, 1945.

Feeling snubbed by Freud in 1938, Dalí searches for ways to look beyond Surrealism and finds the answer in a combination of mysticism and nuclear physics. Mysticism is the "energy" behind Roman Catholicism while nuclear physics and molecular biology—as articulated by the

physicist, Dr. Werner Heisenberg, who replaces Freud as Dalí's new "father" (Dalí's word)—explores the structure of physical matter. Dalí's fascination with both internal and external realities coalesces in this merging of new interests. The result is a glamorized awareness of scientific advances depicted in paintings that reveal an increasingly rich and mystical alternative reality: an exploration of DNA spirals, atomic structure, protons, neutrons, and the underlying physical equivalent of the dream world that has preoccupied Dalí for so many years.

OPPOSITE
Galatea of the Spheres. 1952
25 5/8 x 21 1/4"
(65 x 54 cm)

This merging of his new interests is clear in *Galatea of the Spheres,* in which Dalí employs his technique of double images to create the face of the celestial Gala through a whirlwind of electrons and protons. The hypnotic center of the painting pulls the eye toward eternity.

The most significant work from Dalí's "religious" period is the Crucifixion piece, *Christ of Saint John of the Cross* (p. 97), inspired by

FYI: **Dalí's New Patrons**—The Cleveland art collectors. Reynolds and Eleanor Morse, filled the vacuum left by Dalí's former patron, Edward James. They purchased their first Dalí painting, *Daddy Longlegs of the Evening—Hope!* from Julien Levy in 1943, and by 1971 owned more than 50 of Dalí's most important paintings. Their collection was first open to the public in Beachwood (Cleveland), Ohio, but was relocated to the superb Salvador Dalí Museum, in St. Petersburg, Florida, now home to one of the finest collections of Dalí's art in the world.

a dream in which Dalí saw a nucleus of an atom that symbolically became Christ, "the very unity of the universe." The painting is also inspired by a drawing of Christ that the Spanish mystic, Saint John of the Cross, had done after seeing this vision in an ecstasy. Dalí wants the painting to celebrate the "metaphysical beauty of Christ" and to contain "the most beauty and joy of anything anyone has painted up to the present day." Viewers are fascinated—and a little intoxicated—by the angle of the cross: Christ appears to be floating dizzyingly above the water and rocks of Cadaqués below.

Never one to be outdone, **Dalí demonstrates his new interest in science** by revamping his famous 1931 painting with its scientific incarnation, *The Disintegration of the Persistence of Memory* (p. 99). In this deconstructed scene, nuclear physics replaces the dreaming imagination, and some of the main elements of the earlier picture now appear as microscopic particles, not as a unified whole. The original landscape, once colorful, now hides a vast undergirding of floating blocks and spores. Whereas the earlier painting focused on the inner workings of the mind, this one examines the inner structure of matter. As the watches (i.e., time and reality as we know them) move farther inside the interior of matter, they become less significant and begin to fade away.

Sound Byte:

"I have always been an anarchist and a monarchist at the same time."
—DALI, *Dalí by Dalí*, 1970

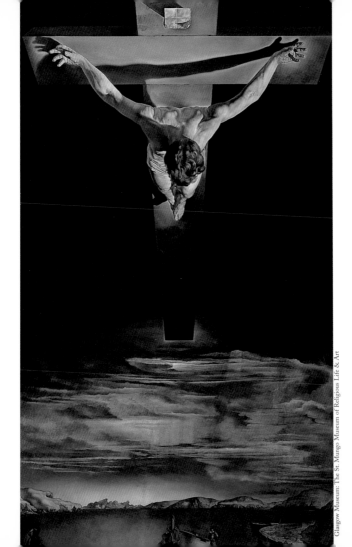

As he pursues scientific subjects, **Dalí also tackles large-scale "history" paintings.** The two finest examples are *Santiago el Grande* and *The Discovery of America by Christopher Columbus* (p. 100). *Santiago* evokes Dalí's "thrill of unity of the Fatherland" in the proud figure of Saint James of Compostela, patron saint of Spain, charging on his horse beneath four jasmine petals that burst into a creative atomic cloud. In *The Discovery of America,* the baroque deification of Gala reaches epic proportions: She looms majestically on a banner, her head radiantly haloed, as the painter's invaluable guide and muse. With a boyish Columbus at her feet, pointing backward toward his ship, the Santa Maria, Gala's robe trails past the boy and connects her with the Carmelite monk (Dalí). Gala glows and the athletic young men (two are nude) are eager to please. Only the monk, crouched over and clasping the Christian cross, is portrayed as old and uncarnal. The painting, a glorification of Spain and Columbus's discovery of the New World, presents Dalí's belief that Columbus was Catalan, not Italian. His patriotism is reinforced by the colorful banners of the Spanish provinces on the right.

By 1959, Dalí spends summers in Port Lligat, autumns in Paris, and the rest of the year in New York—lecturing, making public appearances, illustrating magazine advertisements, and contriving new ways of advancing his fame and fortune.

OPPOSITE
The Disintegration of the Persistence of Memory
1952–54
10 x 13"
(25.4 x 33 cm)

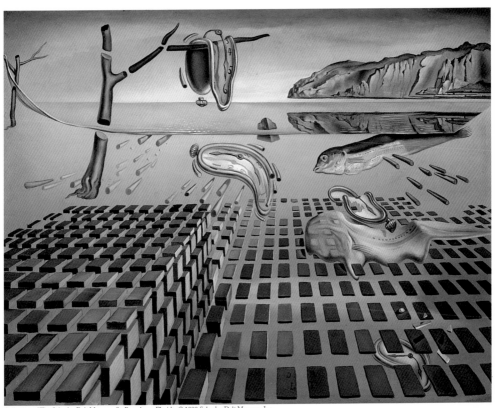

The Discovery
of America
by Christopher
Columbus
1958–59
161 ½ x 122 ⅛"
(410.2 x 310.2 cm)

Santiago
El Grande
1957
160 1/2 x 120"
(407.7 x 304.8 cm)

Twilight of Dalí's Life

Through the end of his life, his work is marked by an unmistakable "Dalí" style: brilliant colors, precise choice of subject matter, perfect perspective, strong composition and draftsmanship, and no small amount of Dalí magic.

The 1960s pass in typical Dalinian style, with Dalí and Gala continent-hopping and myth-making. Dalí claims that Gala's ongoing infidelities leave him time to work, but in reality he is bothered by her adventures. **Gala has become greedier with age and drives Dalí to paint new works to support their lavish lifestyle.** When Gala decides she wants to live in a castle, Dalí buys her one—Castle Pubol—between Barcelona and Figueras. But in 1964, when Dalí and the mayor of Figueras lay the groundwork for a Dalí museum in Figueras, Gala refuses to donate any artwork. Dalí goes ahead with plans for the museum without her.

Dalí's "Court of Miracles"

The aging Dalí is "discovered" by the hippie movement of the 1960s. The generation of "free love," drugs, and spirituality finds in Dalí a guru whose paintings promise enlightenment and self-understanding. Dalí, in turn, embraces the movement and is happy to be back in the spotlight. The roving party of Dalí's friends and admirers is known as the **Court of Miracles** and includes transvestites, aristocrats, hippies, dwarves, and

anyone else who amuses Dalí. From New York to Spain, the artist and his merry band stage psychosexual cabarets and erotic incidents.

A retrospective of his works is held in Tokyo in 1964 and the following year Dalí writes another autobiography, *Diary of a Genius.* The book is of interest for its commentary on "nuclear mysticism" and the importance of the rhinoceros horn as a mystical symbol in his paintings from that period. Such horns represent chastity in *Young Virgin Auto-Sodomized by Her Own Chastity* (p. 111).

From Pencils to Goddesses

One of the most intriguing works from Dalí's later years is *The Hallucinogenic Toreador,* in which he returns not only to the technique of double images, but also to his paranoiac-critical method. Dalí gets the idea for the autobiographical painting from a box of Venus pencils in an art-supply store. The painting is large for Dalí—almost 3x10'—and contains a **double image of Venus de Milo** at the center, facing front and back: To the left of the main Venus figure you see emerge the face of a bullfighter—the toreador—sporting a green tie. Gala's face floats on the upper left (the painting is dedicated to her)

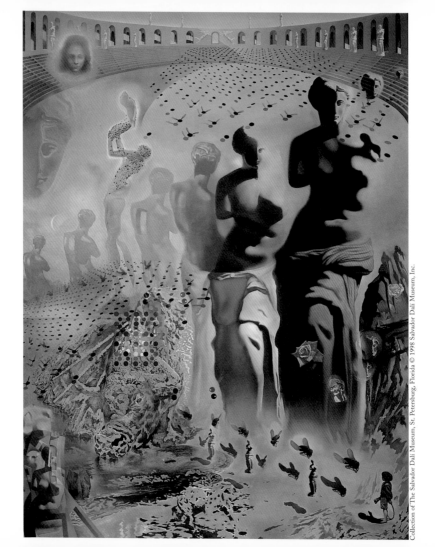

and another double image—a dying bull and the kaleidoscopic colors of atomic particles—occupies the canvas to the toreador's left. (Since this is a dream, or hallucination, of the young Dalí—portrayed in a sailor's suit at lower right, contemplating his future—the painting contains images from the painter's life, such as a Cubist drawing of Venus de Milo, the landscape of Cadaqués, the bullfights, and so on. This monumental work is to be Dalí's last major painting.

OPPOSITE
The Hallucinogenic Toreador
1969-70
157 x 119"
(399 x 302 cm)

The 1970s

Dalí is as famous as any living artist has ever been. He is rich and can indulge his every whim. By 1970, he is worth more than $10 million—many times that in today's dollars. Yet this isn't enough for Gala, who spends money lavishly on their houses, servants, parties, and gambling. She locks Dalí in his studio for hours every day so that he will paint, which strains their relations. In anger, she rakes her ringed hands against Dalí's face if he displeases her. Holed up in Castle Pubol, she carries on with her boyfriends and agrees to see Dalí only if he makes a formal, written request.

Growing Honors Despite the Doubts of Critics

In 1974, **Dalí's Theater-Museum** opens in Figueras. Awards and retrospecive exhibitions continue to be given to Dalí around the world. The French stage a major retrospective at the Centre Georges

Pompidou in 1979; that same year, the Académie Française accepts him into their ranks.

Still, many critics scoff at Dalí as a has-been who has long since cashed in his artistic credibility for commercial success. One review in the journal *Arsenal/Surrealist Subversion* notes that "nothing testifies so clearly to the abysmal ignorance of Surrealism as the fact that it is still widely assumed to have something to do with the antics of Salvador Dalí."

OPPOSITE
Photo of
Salvador Dalí
Paris, 1964

As the Court of Miracles fades away, Dalí begins cultivating the attention of rock stars, including John Lennon, and the art world's new media darling, Andy Warhol. But Dalí is frail and his ability to capture public attention is on the wane. His mental state, too, has begun to deteriorate: He suffers from Parkinson's disease and from anxiety attacks brought on by Gala.

The Print Scandal

To insure that he will benefit from a commercial venture of limited-edition signed prints, Dalí allegedly signs thousands of blank pieces of paper that are meant to be printed later and sold as signed editions. But by the 1980s—so the story goes—art thieves, learning of the signed

Sound Byte:
"Dalí is the only painter of LSD without LSD."
—TIMOTHY LEARY, 1970

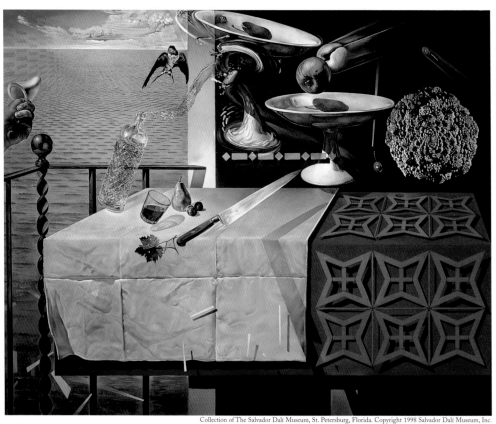

paper, flood the print market with Dalí forgeries, including blank pieces of paper with forged Dalí signatures. The scandal arising from the Dalí forgeries causes irreparable damage to Dalí's reputation, even though there is no hard evidence that he is involved in the forgery.

Final Artworks

Dalí 's last works include an exhibition of holograms in New York and the design of an issue of *Vogue* Magazine. Holograms fascinate Dalí because of their potential for exploring the possibilities of "double vision," a basic tenet of his paranoid-critical method. Though Dalí continues to make art until 1983, his career as a productive, vibrant artist is over by the end of the 1970s.

Gala's last years are an angry blur of dementia. She dies unexpectedly in 1982 and is buried at Castle Pubol. Shortly thereafter, King Juan Carlos of Spain bestows upon Dalí the aristocratic title of Marqués de Dalí de Pubol. This honor does little to boost Dalí's spirits. Despite the pain Gala caused him, her death devastates him.

Dalí lives out his remaining days as a near-invalid, residing in a building adjacent to his Theater-Museum in Figueras. After repeated bouts of illness, alleged suicide attempts, and an incident in which his bed catches fire, leaving him with severe burns, Dalí finally dies of heart failure on January 23, 1989, at the age of eighty-four.

OPPOSITE
Still Life–
Fast Moving
(Nature Morte
Vivante)
1956. 49 ¼ x 63"
(125 x 160 cm)

So....was Dalí Great?

Many people scorn Dalí, calling him slick, commercial, and shrewd rather than talented. Others (this writer included) disagree: Dalí speaks to our fears and obsessions, to rumblings inside and passions unknown, to loose ends that long for connection. Dalí is celebrated; André Breton is unknown.

Dalí's art hangs in major museums, not because it is clever or trendy, but because it reveals dark secrets and strange mysteries of the soul and because people place a high value on it. His posters are bestsellers, not because some PR firm has brilliantly hawked their client, but because people of all backgrounds and ages like his work. Dalí is fun. He makes us laugh and dares us to think. He forces us to participate in his art. We respond viscerally to Dalí, because he relates to us in deeply personal ways.

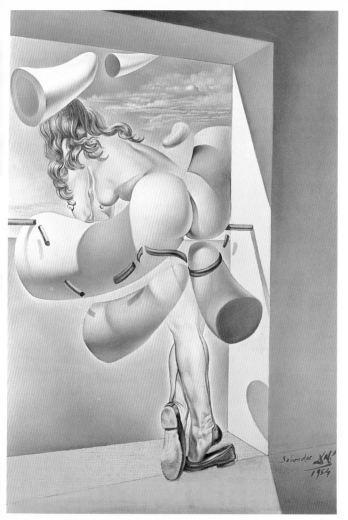

Left: From the Collection of Playboy Enterprises, Inc.
Above: Courtesy of Christie's Images

If we are sometimes uncomfortable with Dalí because his images offend our sense of decency, **we identify nonetheless with his main themes** of memory, dreams, sexual desires, and fears, and with the symbols he uses to illustrate his ideas—from grasshoppers to phallic symbols (lots of French bread!), from lions to melting watches. It surprises us to see how small his paintings are; the Mona Lisa is small, too.

Like many of us, Dalí was an outsider—expelled from school, expelled from his family, rejected by the Surrealist movement, forced to leave Europe during World War II, and even cut off from the public's good will during the print scandal in his old age. Yet he thrives because **his work brilliantly captures a spirit of adventure** and feeds our hunger for answers about the "true" nature of our minds and the world we inhabit.

Dalí reflects an aspect of his times, but is universal in every other way, with concerns that transcend individual cultures. **He is a modern artist,** eager for media attention and for celebrity, money, and acclaim.

So....was Dalí great? You've seen his work and considered his life. Ask your instincts; they will tell you.